SCRAPS

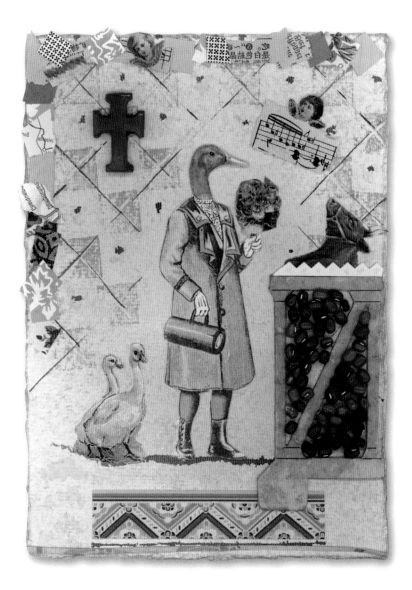

SCRAPS

An Inspirational Field Guide to Collage

ELSEBETH GYNTHER AND CHRISTINE CLEMMENSEN

LARK BOOKS

A Division of Sterling Publishing Co., Inc.
New York / London

Senior Editor: Nicole McConville
Production Editor: Amanda Carestio
Translator: Robin Hansen
Copyeditor: Jacob Biba
Production: Celia Naranjo
Cover Designer: John Barnett / 4 Eyes Design

Gynther, Elsebeth.
　[Scraps. English]
　Scraps : an inspirational field guide to collage / Elsebeth Gynther and
Christine Clemmensen. -- 1st ed.
　　　p. cm.
　Includes index.
　ISBN 978-1-60059-386-4 (pb-pbk. : alk. paper)
　1. Collage. I. Clemmensen, Christine. II. Title.
　TT910.G967 2009
　745.54--dc22
　　　　　　　　　　　　　　　　2009002566

10 9 8 7 6 5 4 3 2 1

First Edition

Published by Lark Books, A Division of
Sterling Publishing Co., Inc.
387 Park Avenue South, New York, NY 10016

English Translation © 2009, Lark Books

Distributed in Canada by Sterling Publishing,
c/o Canadian Manda Group, 165 Dufferin Street
Toronto, Ontario, Canada M6K 3H6

Distributed in the United Kingdom by GMC Distribution Services,
Castle Place, 166 High Street, Lewes, East Sussex, England BN7 1XU

Distributed in Australia by Capricorn Link (Australia) Pty Ltd.,
P.O. Box 704, Windsor, NSW 2756 Australia

If you have questions or comments about this book, please contact:
Lark Books
67 Broadway
Asheville, NC 28801
828-253-0467

Manufactured in China

ISBN 13: 978-1-60059-386-4

First Edition: *SCRAPS – Et kursus I små mirakler*
© 2006 by Elsebeth Gynther and Christine Clemmensen
Published by agreement with Borgens Forlag A/S, Copenhagen, Denmark

For information about custom editions, special sales, premium and corporate
purchases, please contact Sterling Special Sales Department at 800-805-5489
or specialsales@sterlingpub.com.

Thanks to Dover Publications for permission to use clothing from
Antique Paper Dolls—The Edwardian Era for the illustrations on page 2, 30, and 31.

{THANKS TO VIBEKE, FOR OPENING THE DOOR.}

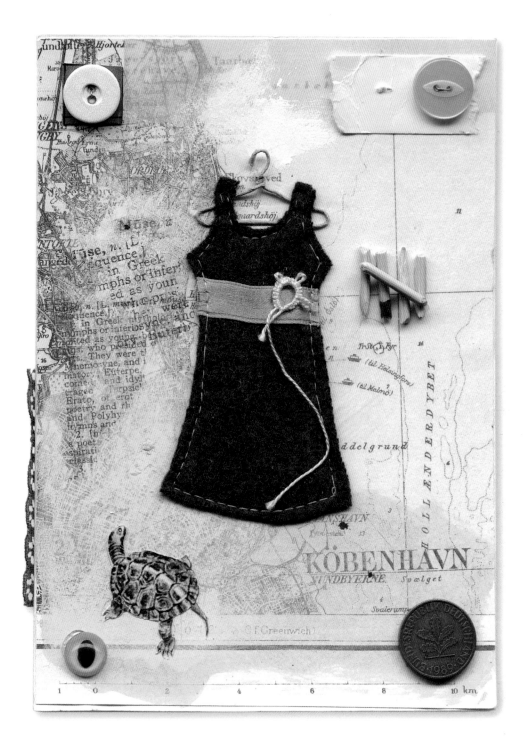

Contents

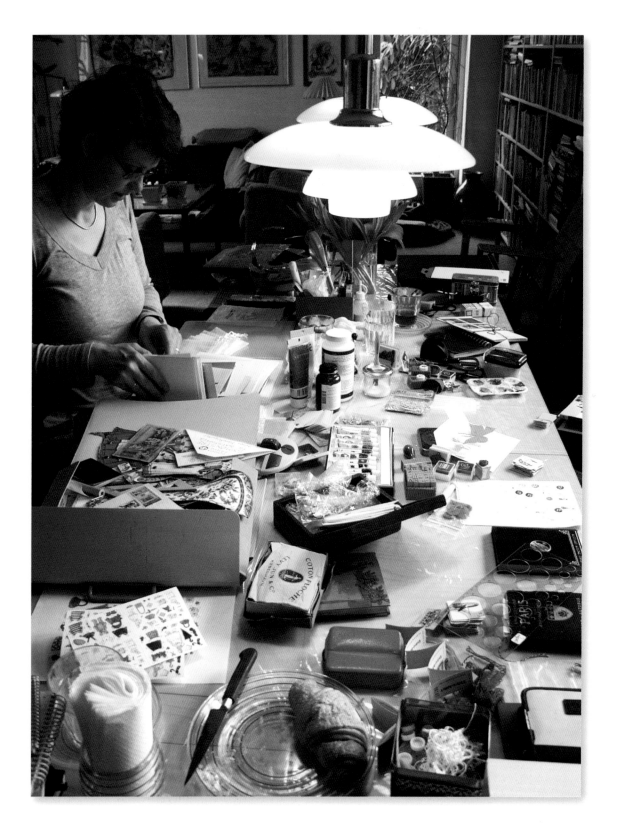

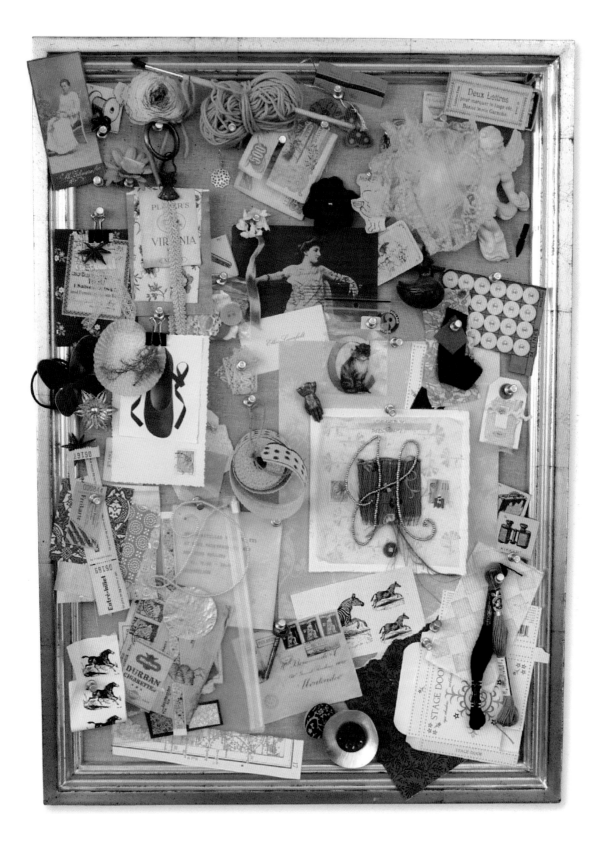

This birth announcement is a combination of cotton paper, a cake wrapper from an Italian supermarket, a cutout, the text of a lullaby from an old songbook, olive tree leaves, and beads.

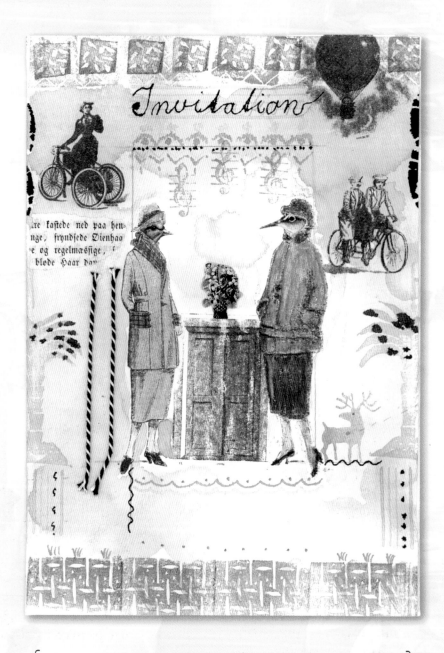

For this birthday party invitation, we applied watercolors, stamps, transfers, cutouts, and string.

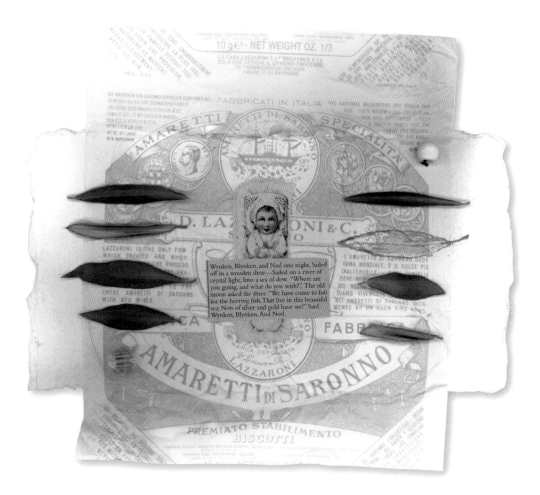

Wynken, Blynken, and Nod one night, Sailed off in a wooden shoe---Sailed on a river of crystal light, Into a sea of dew. "Where are you going, and what do you wish?", The old moon asked the three. "We have come to fish for the herring fish, That live in this beautiful sea; Nets of silver and gold have we!" Said Wynken, Blynken, And Nod.

To Collage Is...

TO PUT THINGS TOGETHER. To combine elements to create something new. Collage is a transformation process in which one thing becomes something else entirely, sometimes with a welter of detail, at other times with surprising simplicity. It's a form of dialogue with the materials at hand. A game, where every little element is a player.

If you want to, you can collage. It's amazing how easily you can create a decorative piece or tell a story. Once you've succeeded, you'll find yourself thinking, "Gee, I could do it this way, or maybe this way, or that way." And then you're underway.

Your goal for a collage may be pragmatic, such as making an invitation to a party, capturing your vacation memories, or creating a picture for the kitchen wall. But your goal may also be simply the desire to lose yourself in detailed work or to disappear into the realm of open possibility, where time doesn't exist—into an almost meditative state, which in itself is a balm for the soul.

In *Scraps*, you'll find inspiration and information about collage techniques to get you going and to help you progress.

Have fun!
Elsebeth and Christine

WHICH COMES FIRST:
THE CHICKEN OR THE EGG?

Anything is possible in collage. What a fascinating realization! But it can also be rather overwhelming when you're faced with a blank page. So where do you begin? And once you've started, how do you know when to stop?

Practically speaking, you start building a collage's background first, but that's not necessarily where the creative process begins.

Inspiration for a collage can spring from almost anything, at any time. There are no rules and no limits other than those you create for yourself. A visual concept forming loosely in your mind, an eye-catching graphic element or image, or even a noteworthy event or memory can easily set a collage in motion. Perhaps a photograph of a relative inspires a card or commemorative piece. Maybe congratu-

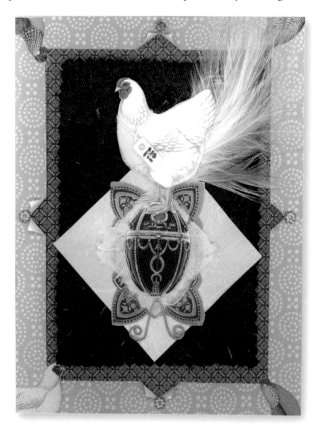

lations are in order for someone significant in your life.

You can also start with a technique that you're experimenting with, or a bare wall in a child's room or the living room. On page 121, you'll find a list of 48 Themes in No Particular Order to help spark your creativity.

There's no right or wrong way to approach the art of collage. Your personality will dictate how the artwork takes shape. Perhaps you're the type who plans ahead, sketching out the finished product before you begin or collecting the materials for the collage months in advance. You could just as easily be someone who finds joy in spontaneity—someone who starts with only a background and allows the piece to emerge almost on its own. But no matter how carefully you plan your creation, be prepared to change gears at any moment. If your collage wants to veer off in a new direction midway through, let it. The results might surprise you.

If you have some materials you want to use but don't know how to do so, sometimes it helps to move them around a little on the background until they find their proper homes. Sometimes, as you're struggling for balance in the composition, your pieces can just fall into place, as they did in the collage above. The border strip at the top, which didn't look quite right anywhere, accidentally slid down the curled paper and landed exactly where it belonged.

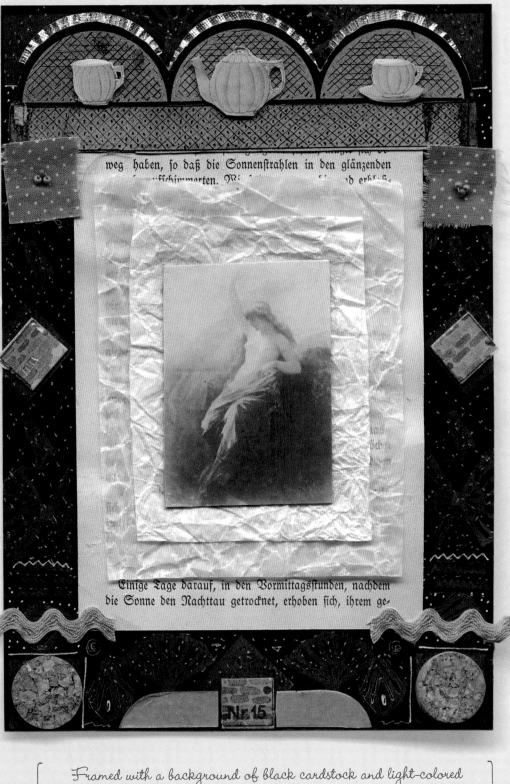

weg haben, so daß die Sonnenstrahlen in den glänzenden

Einige Tage darauf, in den Vormittagsstunden, nachdem
die Sonne den Nachttau getrocknet, erhoben sich, ihrem ge-

Nr. 15

Framed with a background of black cardstock and light-colored
stamps, this piece incorporates a page from a German book, waxed
paper, tissue paper, and small pieces from an old cardboard building set.

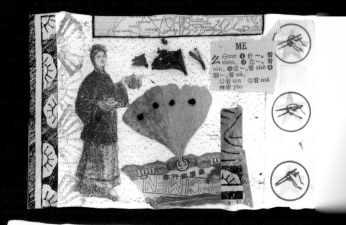

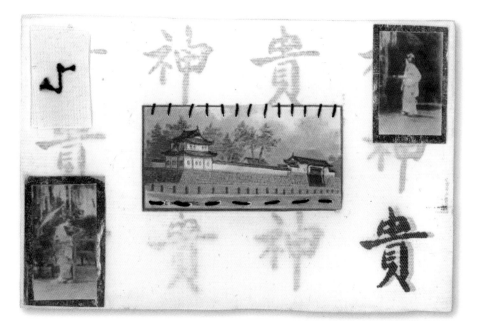

Getting Started

TO CREATE A COLLAGE, all you truly need are the materials you wish to assemble. If you have a particular purpose for your collage, seek ingredients that support that goal. However, it's a good idea to collect a wide range of materials, so that little by little, you build up a good supply of elements that can trigger some additional creative thinking.

Collaging is about making choices, so it's to your advantage to have enough collected items from which to select—different kinds of paper and pictures, ephemera, and effects. With each choice you make, you exclude some options while others

become more apparent. Some choices make themselves, and when that happens, the fun really starts. You open up a dialogue of sorts between you and the collage, in which one choice leads to another and everything moves to a higher gestalt. This won't happen every time, but remember that in general, anything can be changed—or, if nothing else, at least you can make a different collage next time.

But first you have to get started, and that requires materials. On the following pages, read about different ways to acquire them.

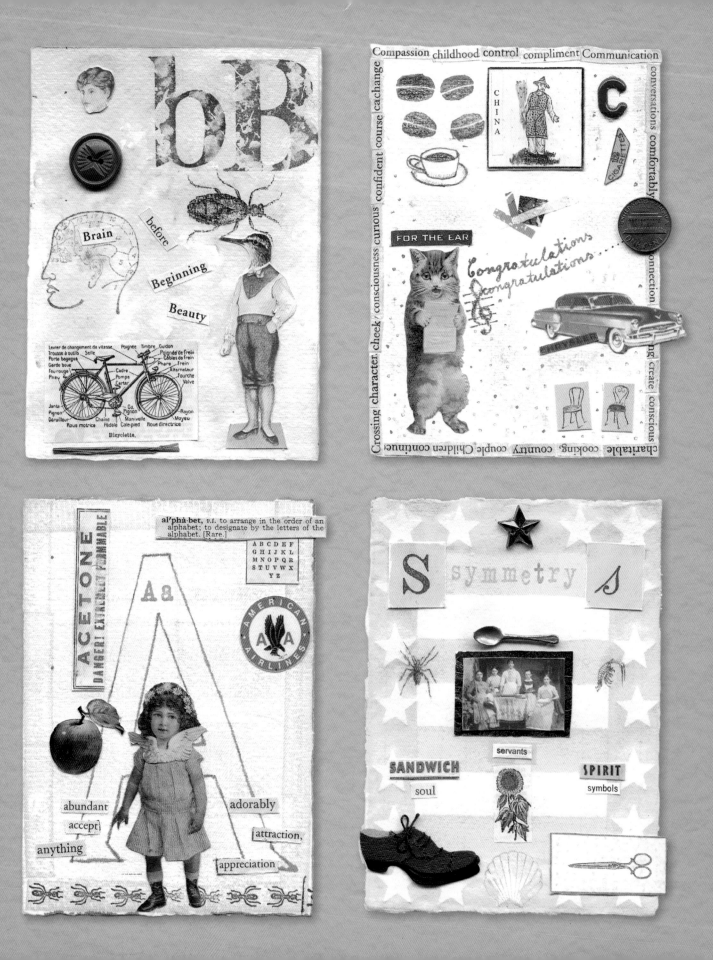

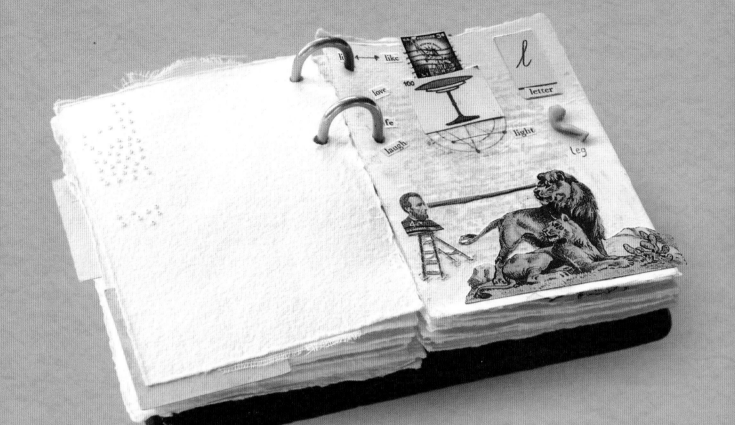

A coffee-table alphabet book is a big project. Take your time assembling it. Start by collecting elements for the entire alphabet, and when you feel you have enough for a particular letter, start working on its collage. Some of the small, square cardboard images here are pieces from old games. Others were handmade with transfers and crayons.

The alphabet shown here serves as a conversation starter for visiting children. We cut out all the single printed words from an old novel.

The background is heavy watercolor paper, hand torn (see page 104) into 3½ x 4½-inch (9 x 11.5 cm) pieces that fit in a desk calendar binder.

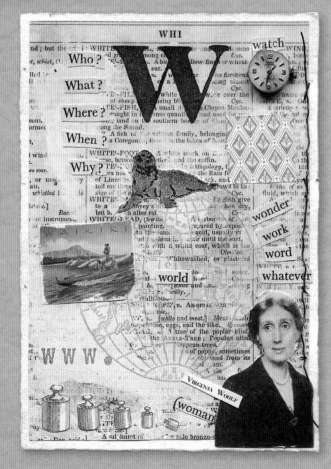

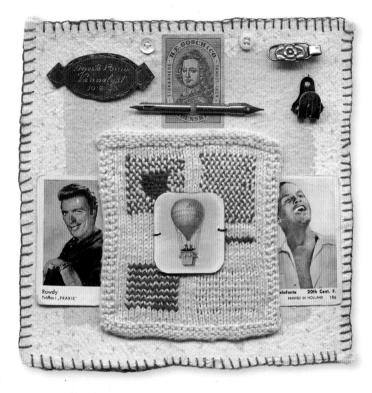

FLEA-MARKET FINDS

Flea markets and yard sales bulge with doodads, pictures, cards, old dictionaries, and other objects to use for mixed media art. It's easy to be overwhelmed by the mountains of stuff, and either suffer shopping paralysis or spend all your money on intriguing curiosities. The goal is to buy the right things for the right price. In the beginning, it's good to stop and ask for prices to get a general price range. Even if a price seems reasonable, you can bargain with the vendor until it matches what you think the object is worth. This isn't always possible, however.

It's a good bet that you'll occasionally leave with something that was irresistible on the counter (and too expensive) but considerably less appealing by the time you get it home. This happens. Seeing the possibilities in an old postcard or book takes a little practice, but if you like something at first glance, look more closely, and buy it if it keeps calling to you. If you're not so sure about something and your money is running low, try talking the seller into holding it for 15 minutes while you walk away. If you can't think of anything except getting back to it, then buy it. But if you see something else right away and forget all about the first item…well, maybe you should do without it

HIDDEN GOODIES AT HOME

You can use anything—or almost anything—for your collage. Rummaging through your closets and drawers can yield surprising and beautiful finds if you have a tendency to save things such as gadgets, clippings, postcards, or whatever you had no use for at the time. And if you can finagle a peek into the storage nooks of older family members who haven't been infected by the simplify-your-life bug, you will often be well rewarded. In such places, you may find photos of their ancestors, receipts for their first dining-room set, long-expired passports, worn-out playing cards, old letters, and all kinds of delicious things.

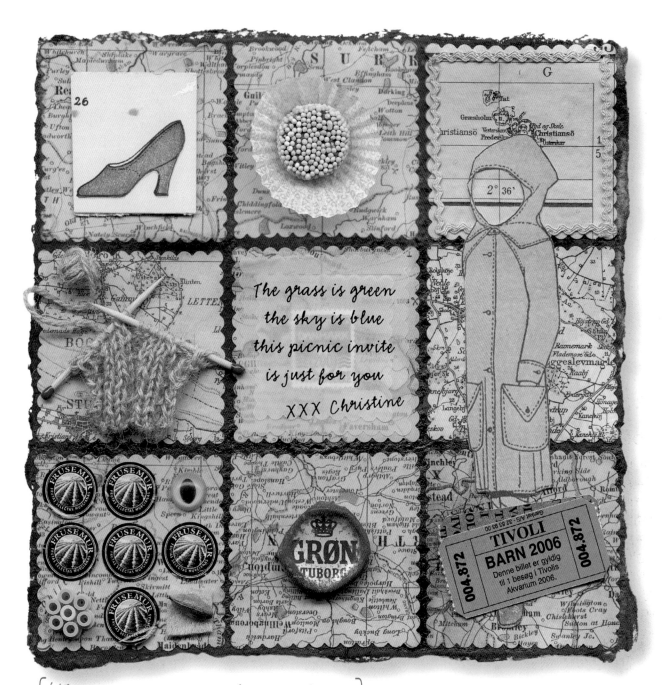

The grass is green
the sky is blue
this picnic invite
is just for you
XXX Christine

{ This invitation to a picnic, with nuances of green,
contains a number of maps, both originals and
copies. The maps were cut to size, pasted, and
shellacked to give the paper a soft golden cast. }

after all. Every now and then you'll come across an object that you know you'll never see again. That's when you must strike. The important thing is to be quick, critical, and quality conscious. Quick, so you spot the object's possibilities; critical, so you only buy what you can really use; and quality conscious, so that you don't come home with a miserable, spiritless thing that will add nothing to your art.

Look around you, and don't hesitate to dig through creepy, old boxes; that's where some of the very best treasures are hidden. And here's some practical advice: carry your money in small denominations rather than large bills, take along a couple of sealable plastic bags for your finds, and don't forget something to eat and drink in case you need a quick energy boost after all that excitement.

You can also find many good things in secondhand stores, antique shops, and used bookstores. These shops are less chaotic than flea markets, and you can get help if you're looking for something particular. However, the prices are often higher, and negotiating can be difficult.

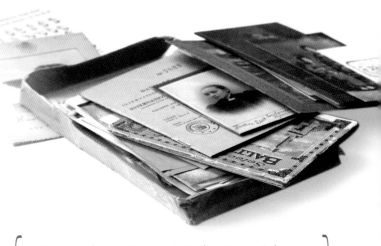

We used this collage to tell the story of how we imagined one of our great grandmothers might have lived. It consists of a monoprint transfer (see page 110); stamps (see page 92); a foil candy wrapper; a coin; and punched, printed, and handmade borders.

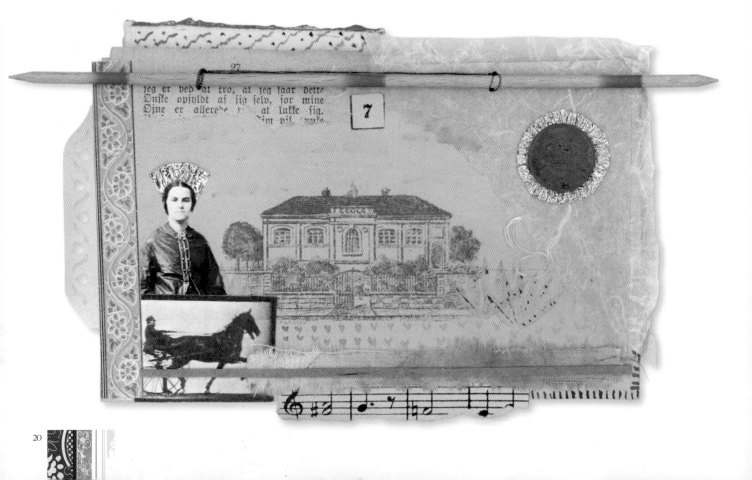

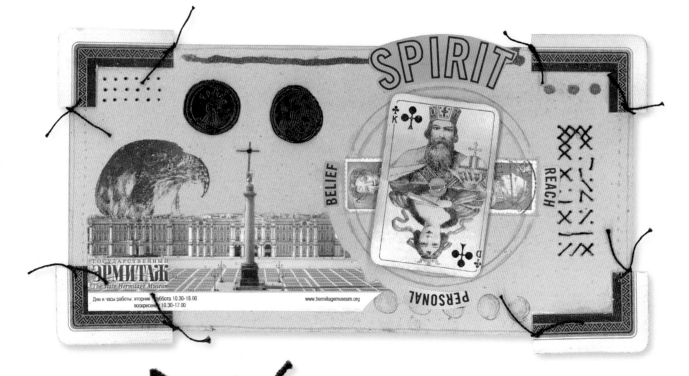

We made this gift tag for our Uncle John, who loves gardening.

EVERYDAY TREASURES

Old things can tell stories. For example, a deck of cards that has spent every Friday in the hands of a rummy-playing family has more to say than a deck of cards fresh from the factory. And so it is with all old things—they carry invisible and unheard histories. But many new objects also have strength. They can be refreshing—and if necessary, you can add a patina to them (see New Becomes Old on page 116).

Museum shops often sell reprints of many old cutout collections and cards, but you can always discover worthy objects in what surrounds you every day: product packaging, trademarks, stickers, pictures, cupcake papers, stamps, sugar packets, matchbooks and matchboxes from restaurants, paper napkins with interesting designs, cigar rings, price tags, pictures from newspapers and magazines—and so forth. You can use an endless supply of things in your art. Put on your collage glasses: there's no limit to the artistic possibilities that you'll find.

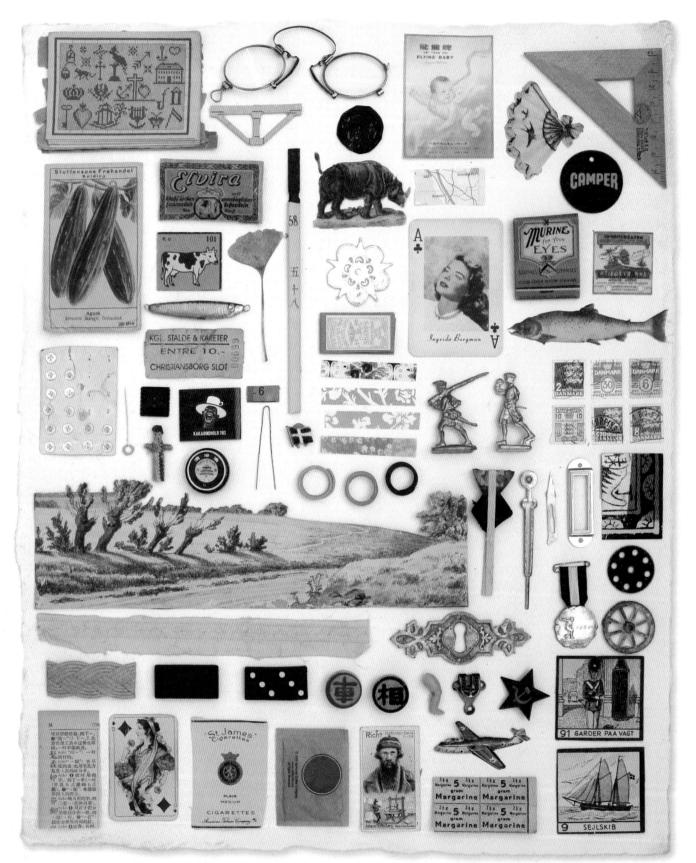

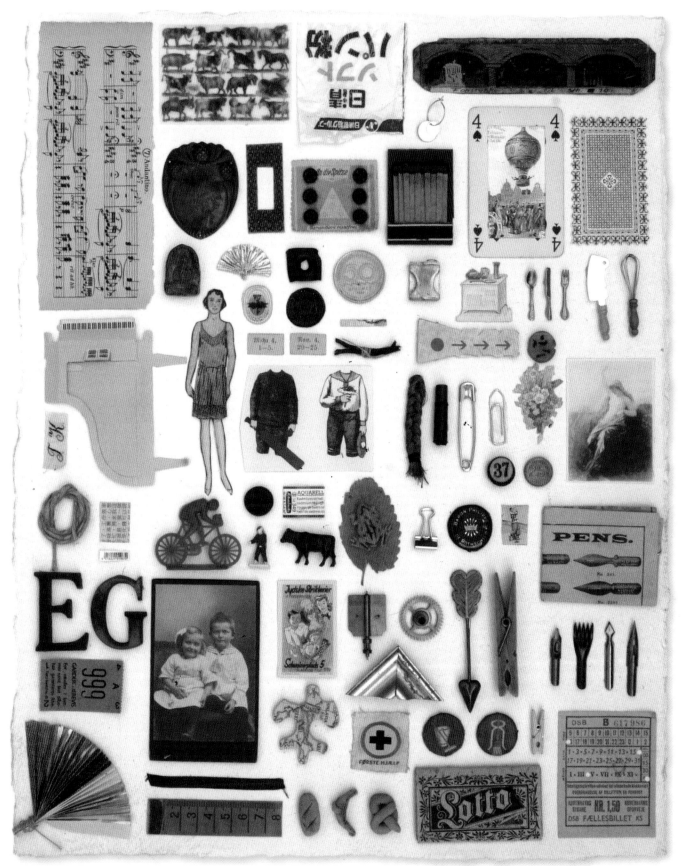

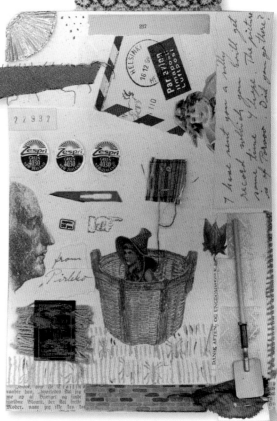

COLLAGE CONTRIBUTIONS

When word gets around that you're assembling collages, friends, family, and colleagues will often present you with bits and pieces for your art. If these contributions don't come automatically, ask for them! You can acquire the most wonderful things this way, and they'll always carry the donors' imprints. For example, you may receive train or theater tickets from foreign places, small decorative stickers from fruit-eating friends, late Uncle Eric's sheet music, peculiar old books from a forgotten bookshelf, and many other delightful artifacts.

STORE-BOUGHT SUPPLIES

A huge offering of paper-crafting stuff is available in craft stores and online—everything from imitation baby shoes, paper numbers and symbols, borders, and copies of old tickets to buttons, charms, stones, and beads. One search for "scrapbooking" with a search engine will reveal an incredible range of possibilities.

There are innumerable online shops where you can find materials for your collages, as well as web pages with free photos for non-commercial use. For example, try www.sensibility.com/vintageimages/victorian or www.art-e-zine.co.uk. To extract images from these pages, you may need a graphics program and a color printer. See Scan, Print, and Photocopy on page 90.

There are many other sites to choose from. Use your search engine to hunt for images or type in "collage." Then stand back as a tsunami of collages arrives. There are also a growing number of online journals—or blogs—created by people who like to share their lives with Internet users all over the world. Search for "collage blog" or "scrapbooking blog," and see what comes up.

Most of the available photos and illustrations are covered by copyright and can't be used without permission from the people who hold the rights to them. Make certain that the material you use is free from copyright restrictions, or apply for permission. Usually, a statement on the home page will indicate if the art can be downloaded or

printed out for private use. As a rule of thumb, get permission if the end use is intended for sale or other kinds of commercial use, as every person who has taken a photograph or drawn, painted, or otherwise produced a picture (and this includes photographers who have taken photos of other people's work) holds a copyright to his or her work.

{ See the full work on page 68. }

THE ORIGINAL OR A COPY

One of the big questions you'll face as you start to collage is whether to use original materials or copies of them in your art. And perhaps there's no right or wrong answer to that question.

Of course, using the only photograph that the family has of Uncle Albert might not be the best idea, so start by working with copies of irreplaceable things. In some cases, the copy may be better suited for tinting or other treatments than the original.

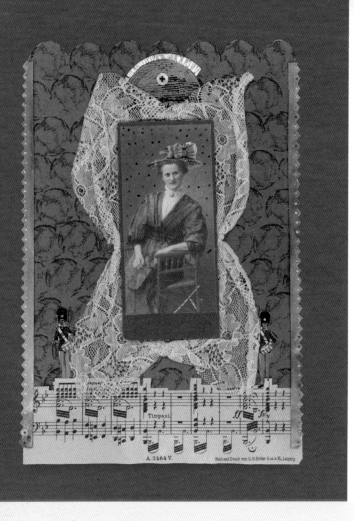

But using nothing but copies can be kind of dreary. For example, you risk a lack of interplay between the surfaces and the quality of paper. (See Scan, Print, and Photocopy on page 90.) At some point, using an especially dear photo that may have spent its entire life in a drawer will be a nice challenge.

It's easy to catch a strange kind of preservation bug, whether it's for family mementos or newly purchased old things. Still, bringing yourself to use them in your collage is hard since there's a risk that you could alter them forever. Giving yourself time helps. Let the objects move into your life, and you'll soon realize that they'll have a much better life in a collage than in a dark drawer. But using them does take courage.

COLLECTING IDEAS

When you have an idea you think you'll be able to use, make a note of it. Ideas have a tendency to disappear if you don't record them—especially ideas that appear in the middle of the night. Keep a pencil and paper beside your bed. Create a special journal for notes and sketches. If a certain picture or item has inspired a collage, put it in a sealable plastic bag or in a folder with a sketch of the idea.

When one of our elderly aunts died, she left behind a pile of family photos, doodads, and other saved things, as well as ration stamps and purchasing cards from World War II. Everything in this book was made with original materials; nothing has been photocopied.

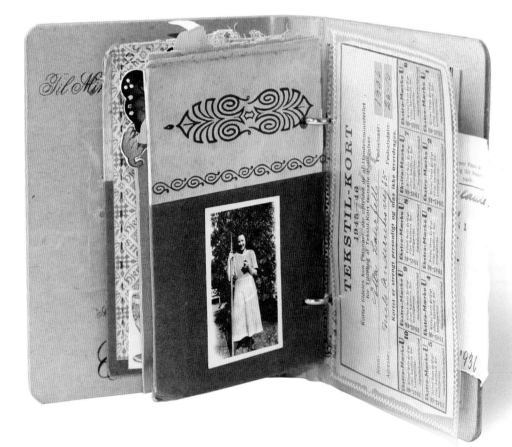

To protect old photographs, we use acid-free glue. Read more about this in the glue section on page 108.

This textile card (a ration card), which we couldn't bring ourselves to cut or glue, was sewn into a plastic sleeve, and thus protected and preserved.

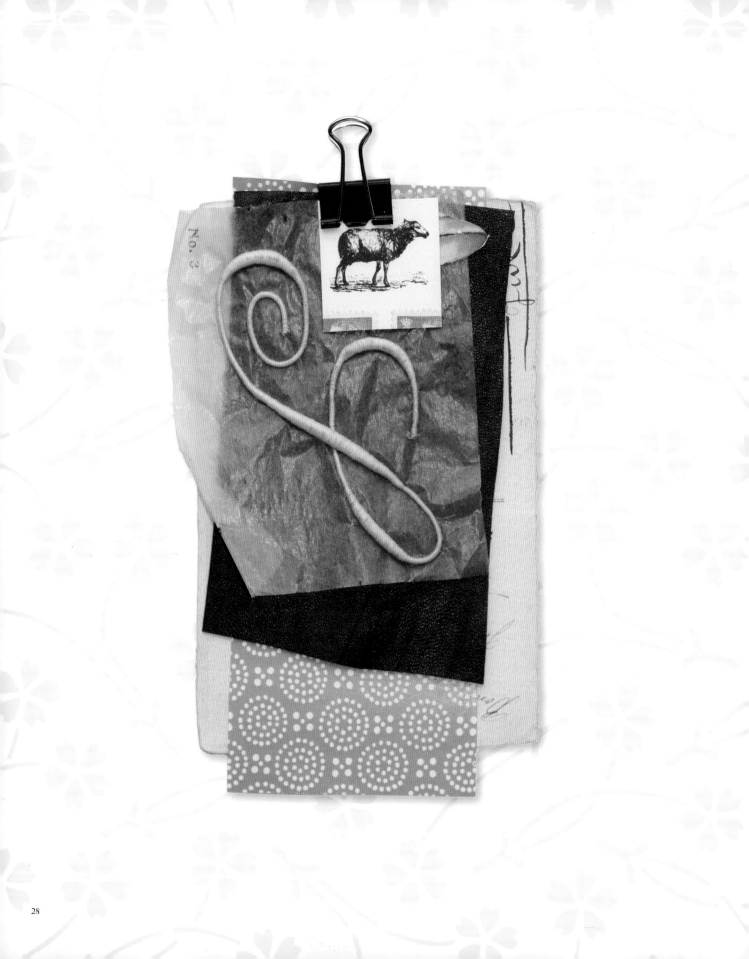

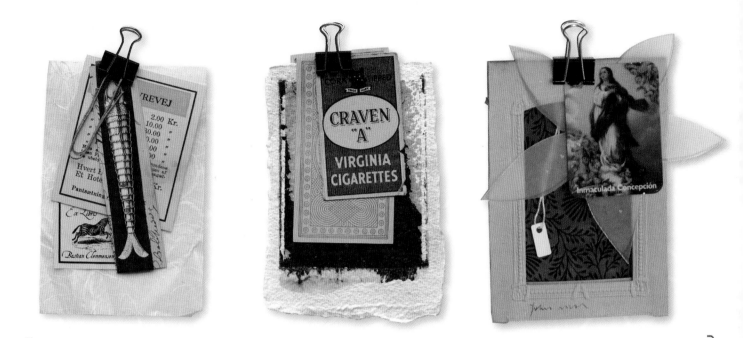

{ These clusters of "ingredients" can be hung on the wall, a bulletin board, or wherever you'd like to see your finds. Using binder clips to keep elements together is an easy way to exhibit them without gluing or cutting them. }

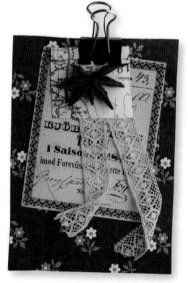

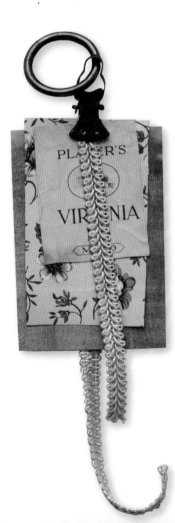

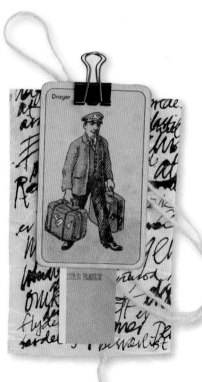

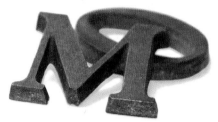

CREATIVITY LONG FORGOTTEN

Maybe getting started isn't easy for you. Not being used to unfolding your creativity and your imagination can affect your self-confidence, making you feel hopeless and nervous about not doing a good job. If you've closed the door to your inner creative workshop, you may have to call on all your strength to crack it open again. Creativity is a basic material—it can take many forms and express itself in innumerable ways. First and foremost, it's the ability to see possibilities and combinations, whether in mathematics, words, movement, music, or fashion. Many people use their creativity in just one way, and that suits them well, but as a rule, redirecting your creative impulses to another medium isn't that hard. If you want to! Because we often become best at the things we want to do.

If you left your creativity in the playroom with your toys, we can assure you that it's still there. Just show it the light of day, give it water and fertilizer, and it will grow once again. It doesn't matter how uncertain or clumsy you feel now. Know that the desire to make something is a call for help from your imprisoned creativity. It wants to be released. Don't worry: you can start your collages in private, or you can find another novice to start with you.

The inspiration for these collages occurred when we came across Dover Publications' Antique Paper Dolls—The Edwardian Era. Because the collages were for publication rather than personal use, we had to ask the publisher, who owned the rights to the paper doll images, for permission to use them. (See page 4.)

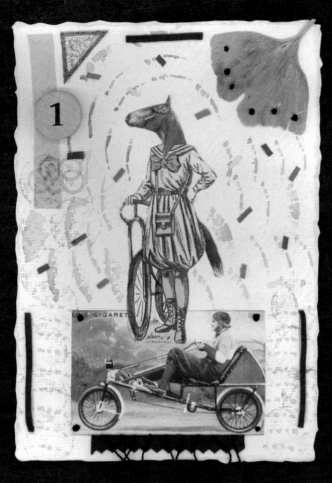

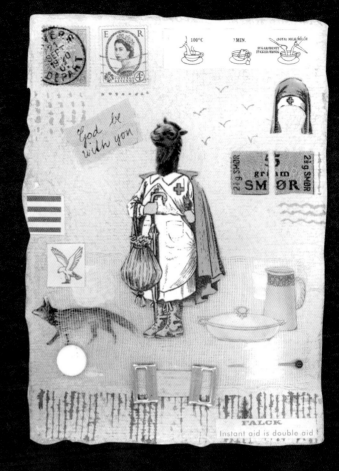

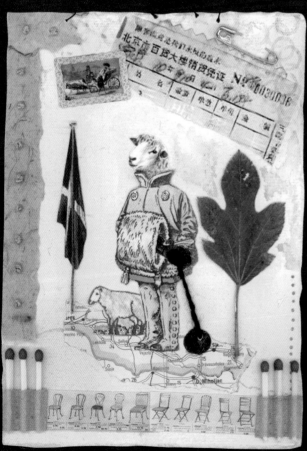

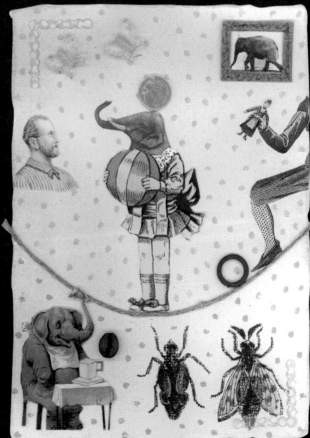

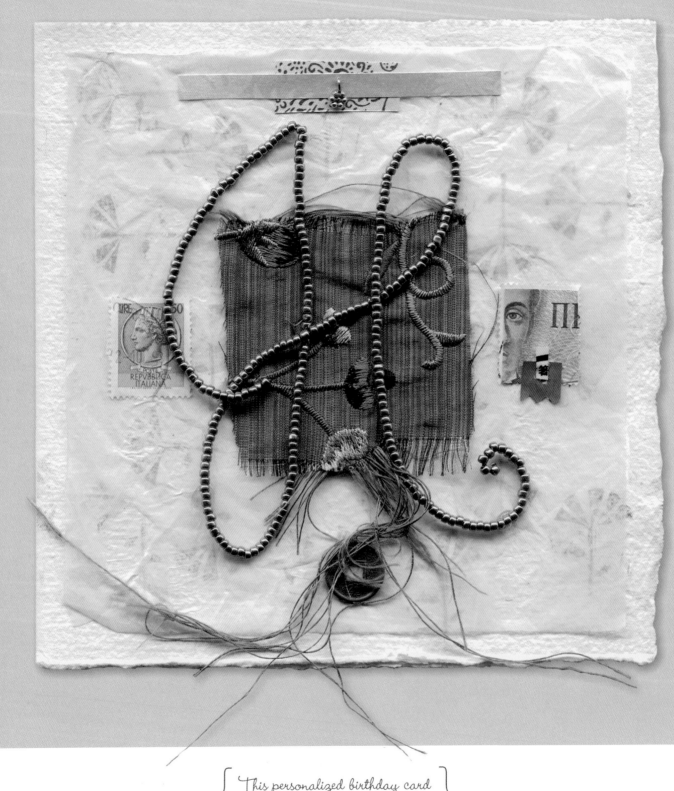

{ This personalized birthday card features the recipient's initial. }

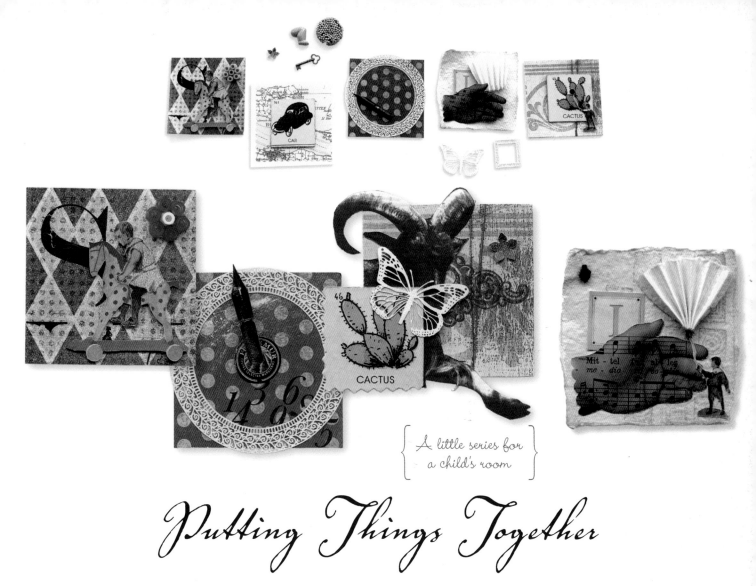

{ A little series for
a child's room }

Putting Things Together

AFTER YOU'VE GATHERED the materials for your collage, it's time to do something with them. Make your first choices—then open the ballroom doors and let the dance begin! You have room for all kinds of steps, movements, and music. When you're ready to start adding items to the background, take a freestyle approach.

As you add more and more to a collage, you may have to accept that the picture itself has become a participant in the decision-making process. Maybe the background only needs one or two more items before the collage is finished. Maybe you'll have to experiment with a number of materials on the collage before you decide that it has the balance and harmony you're seeking. Sometimes, a collage conceived as a decorative piece suddenly takes on its own life and demands that you tell a different story altogether. Let it speak.

If a project seems overwhelming before you've even begun to work on it, pages 52–67 offer a variety of structured ways to start your collage—but don't feel as if you're bound to one of these suggested work plans. A suggestion is only a nudge in a new direction or toward a new, refreshing idea. It's not meant to restrict your creative growth.

In the next few pages, you'll find information on different types of paper for the background and its decoration.

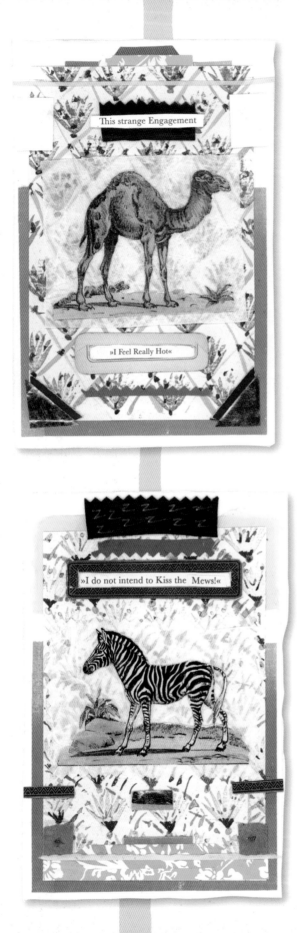

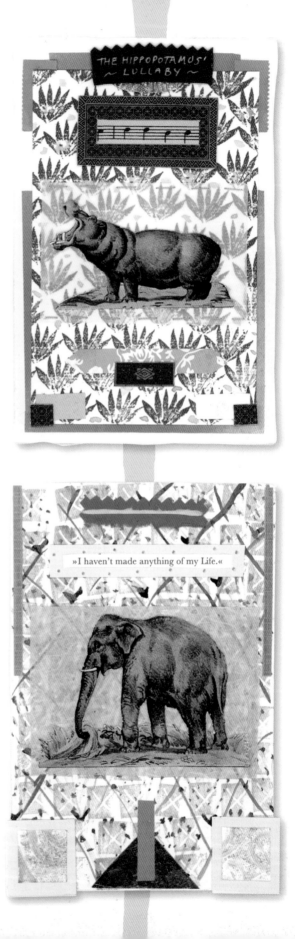

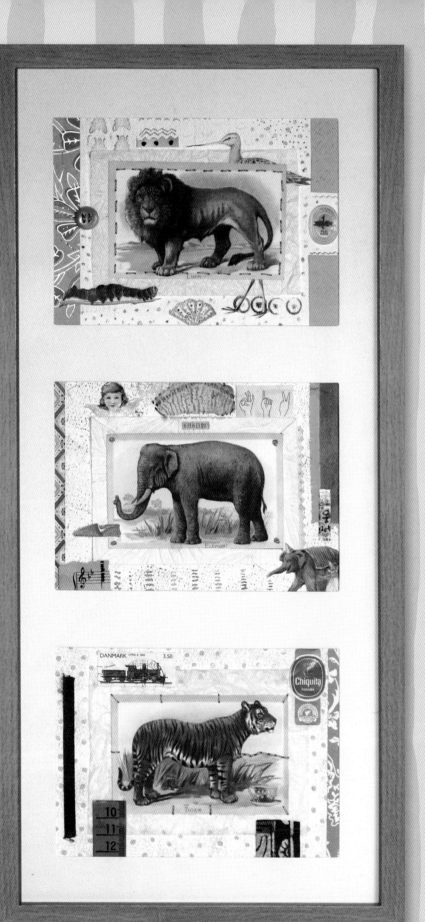

{ Pictures for a child's room }

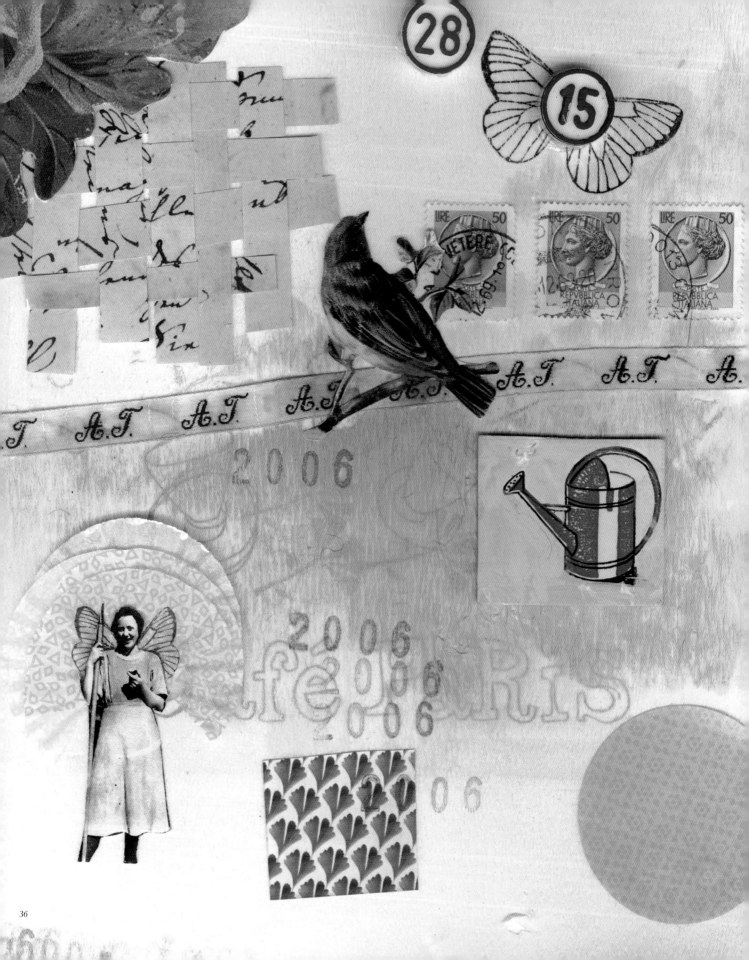

{ Unfinished collage }

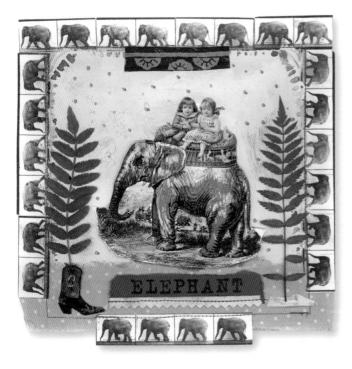

{ Gummed mounting tape }

THERE MUST BE SOMETHING BEHIND THIS...

Practically speaking, collaging begins with a background, no matter what you plan to do. The background—the surface the collage is built upon—can be described in terms of quality/structure, shape/format, and color/pattern. These characteristics set the stage for the work that follows. Most paper bulges when it comes in contact with liquids, so the paper you choose will depend on whether you plan to use liquid-based paints—such as watercolor, gouache, or India ink—or dry coloring tools, such as colored pencils or pens. (See pages 88 and 89.)

For a simple collage with a couple of picture cutouts and a few stamps, you can work with white or colored paper, thin watercolor paper, or light cardstock as a background. However, with a collage that will support three-dimensional objects, you'll need to use a heavier background. Keep in mind that some heavy cardboards and papers can be difficult to poke holes in or sew through. If you choose lightweight paper—which can be a paper pre-adapted for collages or alternatives such as sheet music, newspaper pages, and maps—it might be a good idea to bond it to a heavier material.

If your background bulges, flatten it by sticking gummed mounting tape—usually used for mounting watercolor paper—onto the back. This tape works on the same principle as a postage stamp. If the piece in question is larger than a stamp, though, use water rather than your tongue to wet the gummed side.

Another thing to keep in mind is your paper's acid content. Acids decrease paper's durability, so if you want a collage that will last for years, use acid-free materials. Newspapers and magazines are usually printed on paper with an acid content. However, many books, as well as clipart and cutout picture sheets, are printed on acid-free paper.

For simplicity in the pages to come, we've divided paper types into those with solid-colored surfaces, hand-manipulated surfaces, and preprinted (or manufactured) surfaces.

SOLID-COLORED SURFACES

HAND-MANIPULATED SURFACES

PREPRINTED SURFACES

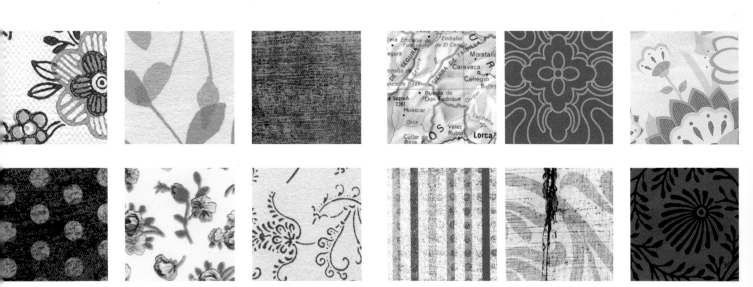

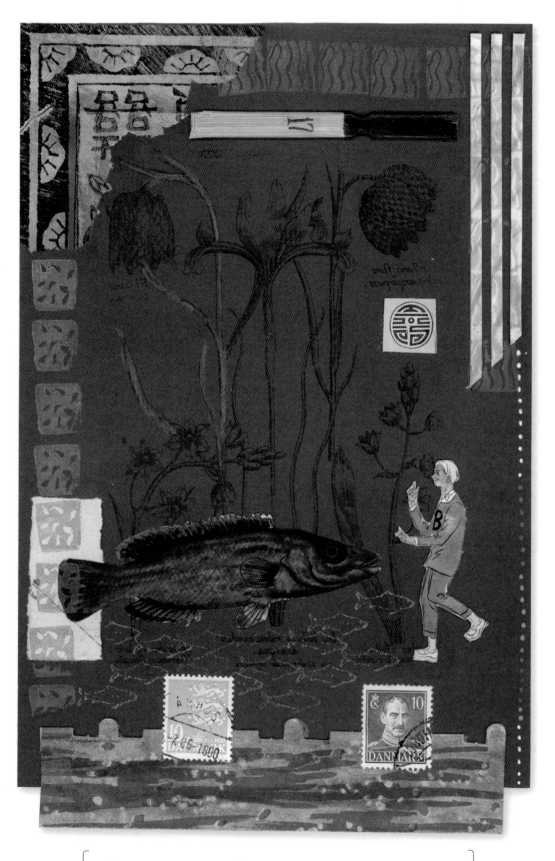

{ A birthday card for Benjamin, who is crazy about fishing }

Solid-Colored Surfaces

With a solid-colored surface, the effect of the collage you're aiming for will be determined by the quality, texture, and color of the paper you use. The quality is affected by the fiber type, the weight, and the method of construction. The texture is the character of the surface: it can be nubby, rippled or ribbed, smooth and glossy, matte, rough, and so forth.

When it comes to color, choose one you like. If you've already selected elements and motifs for the collage, choose a background color that matches or, at the very least, "speaks to" to what you've planned. Remember also that white paper comes in many shades that can have different results: an unbleached white, possibly with some surface structure, will provide a softer expression than a chalk-white, glossy surface.

The quality of monochrome paper can range from discount paper at the supermarket to expensive, handmade papers. Heavy envelopes, packaging, and other recycled materials are quite usable as well, so keep what you come across, even if you don't need it right that minute. A variety of light, transparent (and semitransparent) papers is also available for you to use, including tracing paper, vellum, tissue paper, rice paper, and waxed paper—what we call "effect papers."

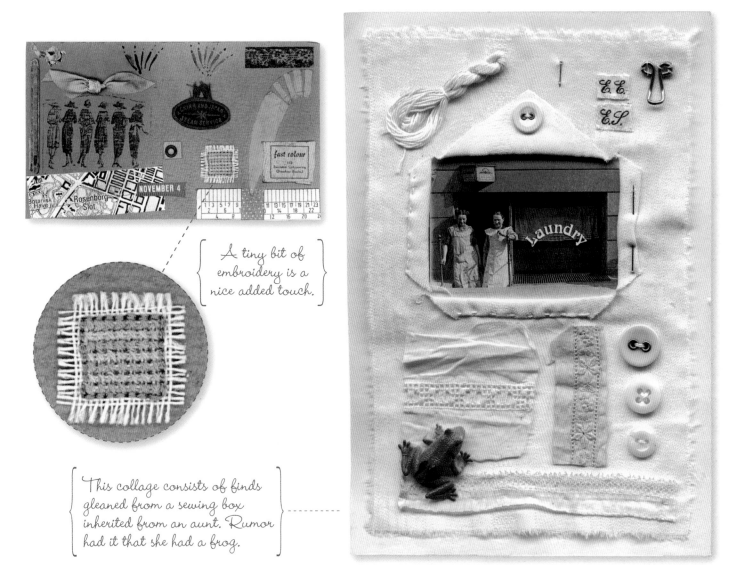

{ A tiny bit of embroidery is a nice added touch. }

{ This collage consists of finds gleaned from a sewing box inherited from an aunt. Rumor had it that she had a frog. }

The recipe for one of our favorite soups is written around the edge of this collage. The tiny "napkins" are made from folded wax paper.

Hand-Manipulated Surfaces

As an alternative to using store-bought solid-colored paper, you can create the paper's background color or pattern yourself, which can generate options for a more lively surface. If you choose this approach, be sure to select a paper that's strong enough to withstand what you're going to do to it. Altering the paper's surface to achieve a certain effect may limit the techniques you can use to layer items on top of the background. For example, if you make a background paper glossy by varnishing it, painting or adding stamps may be more difficult than they would be on a paper with a flat, matte surface.

You can add your own colors and decorative effects to your background with stamps, brushes, pens, colored pencils, oil pastels, and crayons (see page 88–92). Tea, coffee, and a turmeric bath can also create exciting effects (see page 106), as can transfers of patterns and motifs (see page 110). When the collage is completed, you may want to coat certain parts or areas with matte or glossy decoupage lacquer, which is clear, or with shellac, which creates a golden sheen. However, once you've painted over the collage with your lacquer brush, you've limited further work on it because of the change you've made to the paper's surface quality.

The background patterns in the collage above and on the opposite page were imprinted with stamps cut from erasers. (See page 97.)

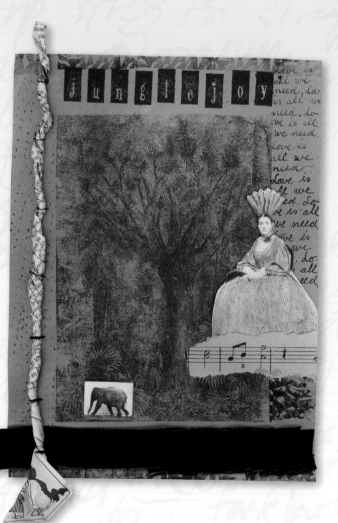

This background consists of a brown envelope with a jungle motif transfer, stamps, and handwriting. (See pages 24 and 25.)

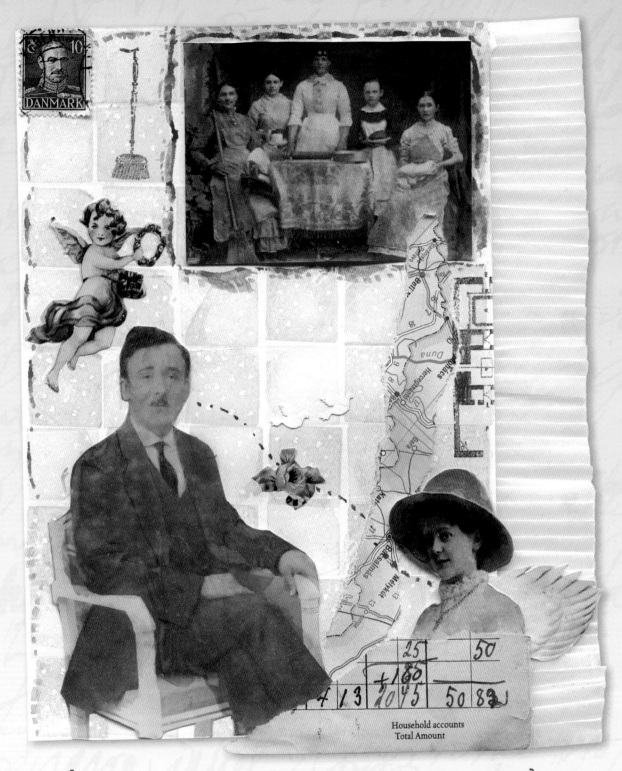

DANMARK 10

Household accounts
Total Amount

We don't know who the people in this piece are, but we like to imagine that the collage tells the story of a man who defies his family and falls in love with a beauty from the city. The background is stamped, the applied border on the right is pleated wax paper, and the small doves are store-bought. The photographs were brushed with decoupage lacquer.

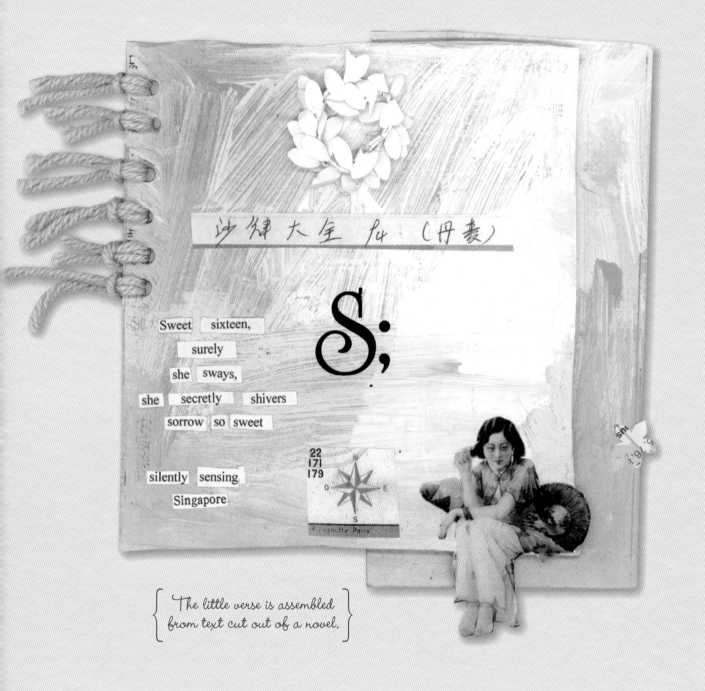

沙律大全 ʃu (丹表)

S;

Sweet sixteen,
surely
she sways,
she secretly shivers
sorrow so sweet

silently sensing
Singapore

22
171
179

F. Lagoutte. Paris

{ The little verse is assembled
from text cut out of a novel. }

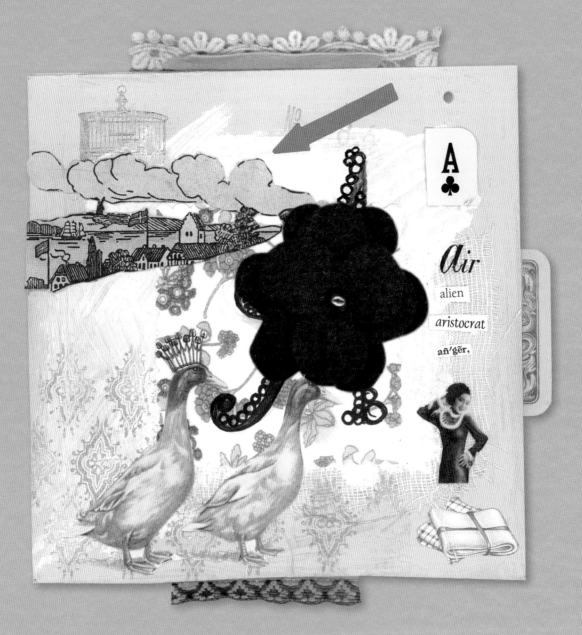

{ These are two examples of hand-manipulated surfaces. The cards were built on thick cardboard painted with gouache and acrylic paint. The colors were mixed directly on the cardstock. }

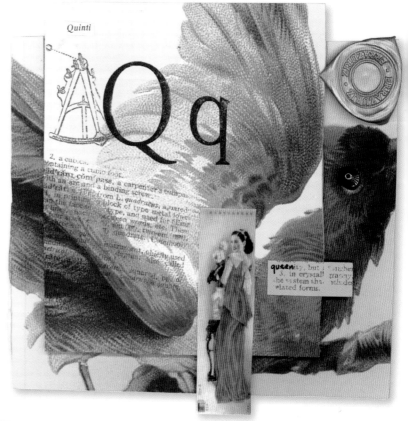

{ *Alphabet series continued from previous pages* }

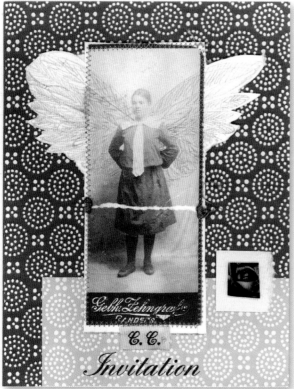

Preprinted Surfaces

Patterned paper can include anything from printed paper with some form of design on it to printed music sheets, maps, newspaper illustrations, book pages, photos, letters, documents, and postcards.

You'll have many options if you choose to use preprinted paper. You can purchase it in art supply stores, craft stores, and online in both small and large formats. Just be aware that many shiny, smooth papers—such as wallpaper, for example—can be more difficult to paint, print, or stamp on than matte papers.

Brightly colored or high-contrast patterns on your background will require more of a challenge from the other elements in your collage than subdued patterns will. If you don't want the background to draw all the attention, you can tame it with various techniques or with effect papers (see page 41) and colors (see page 88).

Breakfast

Lunch or Supper

Afternoon Tea

Dinner

1263

Shopping list

Eggs
Juice
cauliflower
flour
bananas
laundry detergent

SHAPE AND SIZE

The size and shape of the background play an important role in the appearance of the finished collage. Of course, you can let some elements bleed beyond the edge of the background to change the shape that way, just as you can trim away the background as you work. See the section Snip, Cut, Tear on page 100 for suggestions on how to do this.

The purpose of your collage may predetermine its size, but this may not be the case if you're throwing yourself into free, spontaneous art. Think about the sizes of the individual elements you have in mind and choose a format based on them. If you're just starting, a large format can be overwhelming. Even 7¾ x 7¾ inches (20 x 20 cm) may be too big to start with, causing an unhappy beginning for your collage career. Starting small is easier, no matter how trivial the size may seem. A couple of successful collages, each the size of a postcard—or even smaller—will be enough to give you a self-confident debut.

For comparison, the actual dimensions of all the works in this book are listed on page 126.

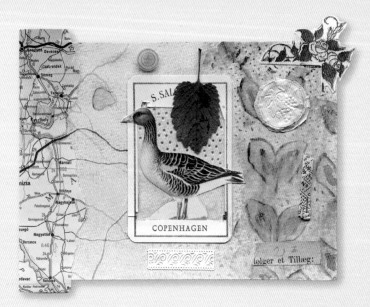

The three-dimensional birthday collage above includes a letter closed with sealing wax.

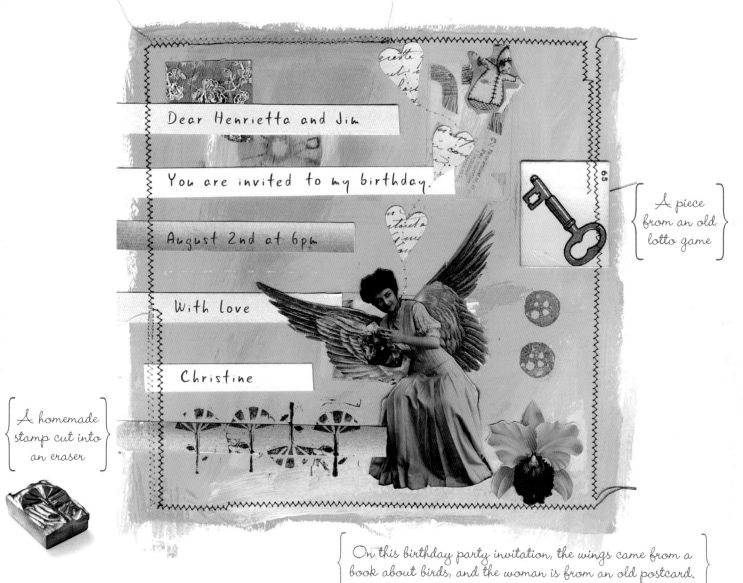

Dear Henrietta and Jim

You are invited to my birthday.

August 2nd at 6pm

With love

Christine

{ A piece from an old lotto game }

{ A homemade stamp cut into an eraser }

{ On this birthday party invitation, the wings came from a book about birds, and the woman is from an old postcard. }

FORM AND COLOR

The background color sets the tone of your piece. The elements you add generate contrast and harmony, becoming principal parts of the finished collage. These elements and the background color are participants in a dialogue that takes place between the different devices you use. There are many ways to create color harmony, but a common denominator is always a good idea. Try starting with a few colors that work well together. Which and how many is a question of taste. Color harmony is a delicate affair and can be attained in numerous ways; often you need only a single dot or a strip in a different color to create contrast.

The colors can be related in various ways: They can all be red tones, for example. They can have the same degree of lightness (such as pastels), clarity, or weight; they can also be cold or warm, illuminating or subdued. Using many colors can be gorgeous, but if you feel that the collage has become a messy and hysterical expression, you can limit the range of colors; simply tone it down by painting over the collage or covering it with an effect paper or a fabric such as cheesecloth. You can purchase the latter in various weights, giving you control over the degree of transparency.

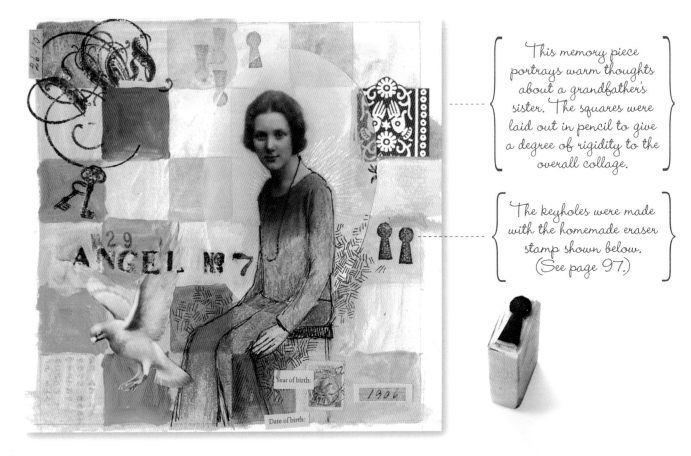

This memory piece portrays warm thoughts about a grandfather's sister. The squares were laid out in pencil to give a degree of rigidity to the overall collage.

The keyholes were made with the homemade eraser stamp shown below. (See page 97.)

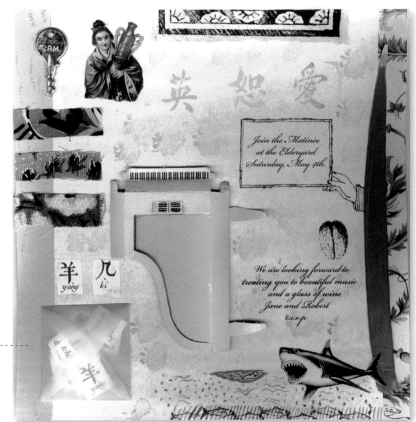

This light green piano image lay in a drawer for many years. The collage was originally assembled for another purpose but was saved and resurrected as an invitation to a concert.

The envelope is folded tracing paper.

Leonardo da Vinci's Vitruvian Man was the starting point for this collage; the original intention was to create a collage in terra-cotta colors with only a few contrasts.

The scallop shells were printed with an antique lead stamp. The background was drawn with colored pencil.

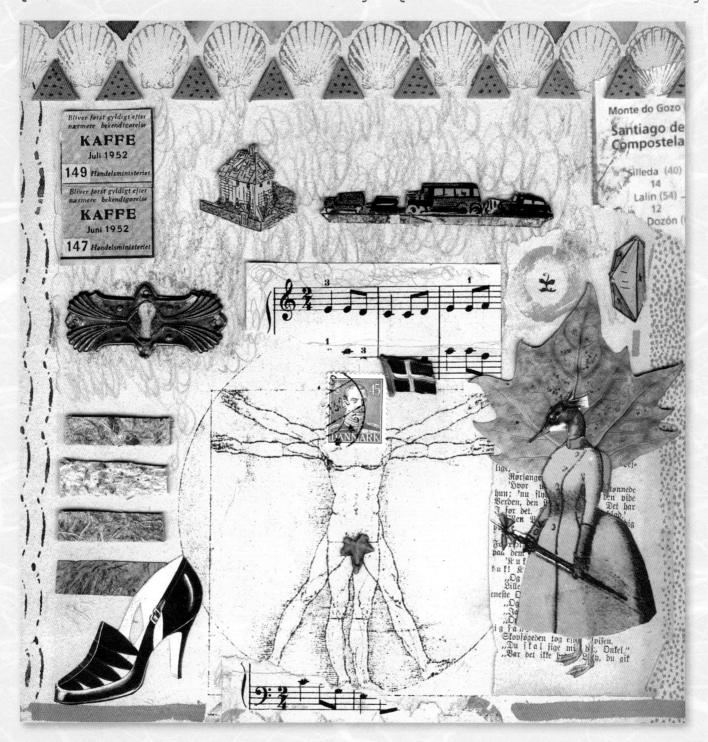

COMPOSITION

Composition is the formula that, consciously or subconsciously, underlies a collage. You'll often find that you have serendipitously or impulsively built your collage on classic lines, simply because these rest on a sense of natural balance.

{ *The edge is finished with small narrow notches made with scissors.* }

Begin Simply

Find three to four pieces that you feel absolutely must be in the collage, and try them out in various places on the background. Push them around in relation to one another until a harmonious arrangement develops. If something is lacking, dig into your caches, add color, stampings, or other effects, or try an extra layer of paper. Don't glue any components onto the background until you feel certain that they're in the right places. Then decide whether you should work on the background or the elements further.

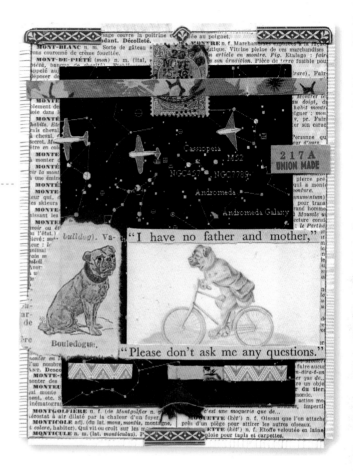

Main Characters, Extras, and Setting

If you think of a collage as a kind of theater, you can begin by choosing a principal character, then the extras, and finally, the setting for the scene (part of which is the background). Viewers attain a certain calm when their eyes are led around the composition. In this technique, the chief character is largest, the extras are smaller, and the background is dark and doesn't force itself on the eye. In this way, the viewer automatically sees the chief character first, then the extras, and finally the background.

If you have no priorities, you risk creating something in which all the parts are the same size, with the same visual weight. This causes the viewer's eye to zap from one element to the next, without actually taking in the intended story of the collage.

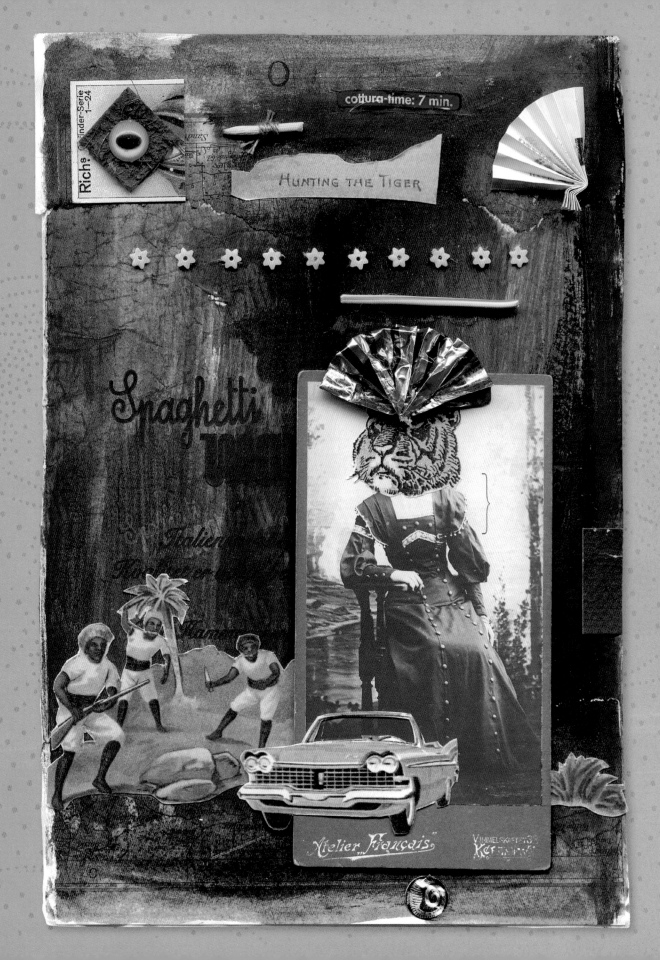

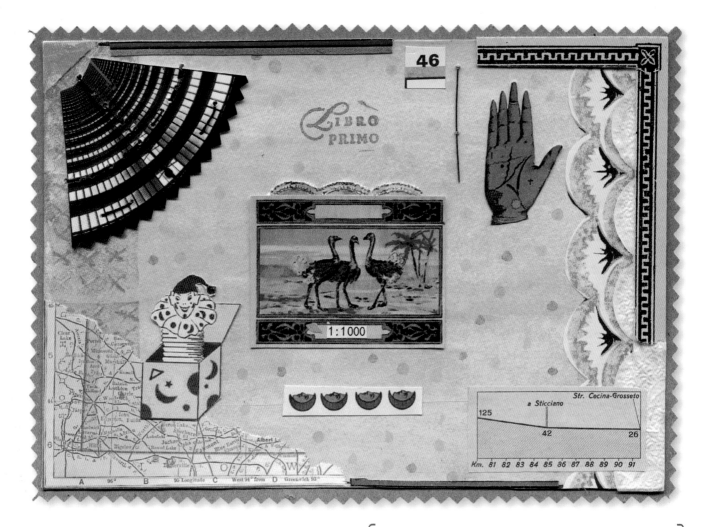

Central Motif

If you have a strong motif element, you might begin by placing it in the center and then working your way out toward the edges, filling in the collage with ephemera and technical effects. This creates immediate harmony, emphasizing the particular motif in an effective way.

The ostriches are from a sheet of textile trademarks purchased online. The motif in the upper left corner is from a vacation photo of the roof of the Milan railway station in Italy.

In from the Edges

You could also begin with the frame and work your way in toward the center. Remember that a frame doesn't have to be the same all the way around, and it can be made with diverse elements. Unless you want the frame to be the bottom layer, waiting until some of the other elements are in place before you glue it down is a good idea.

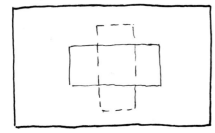

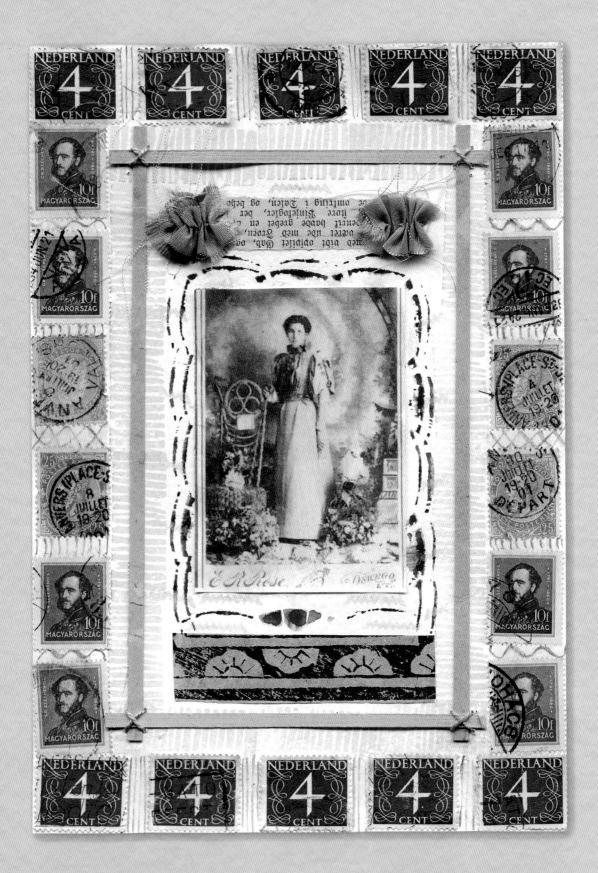

{ The columns are from a postcard, and the building is from a sheet of printed paper. The background was dotted with India ink. }

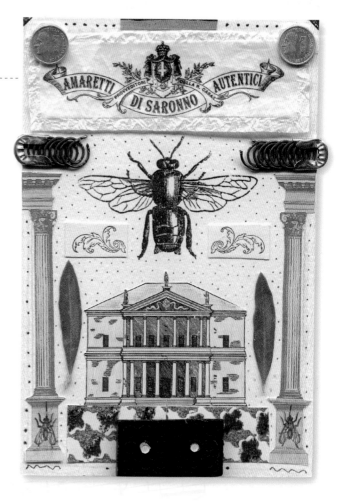

Symmetry

Start by building mirror images around a vertical central axis. You don't have to use symmetrical or mirror images, as long as the elements balance each other in relation to the central axis.

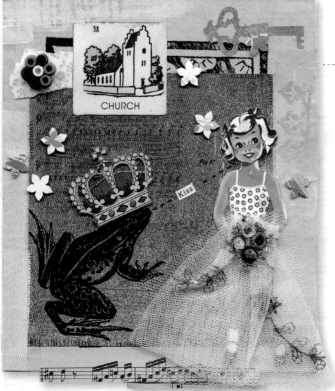

{ The text —"Thank you for the lovely wedding gift"—is on the reverse of the card. }

Asymmetry

Choose two to five elements with almost the same strength but not necessarily the same size. If they have the same strength, they'll draw equal attention. Play with the placement until you find an asymmetrical balance.

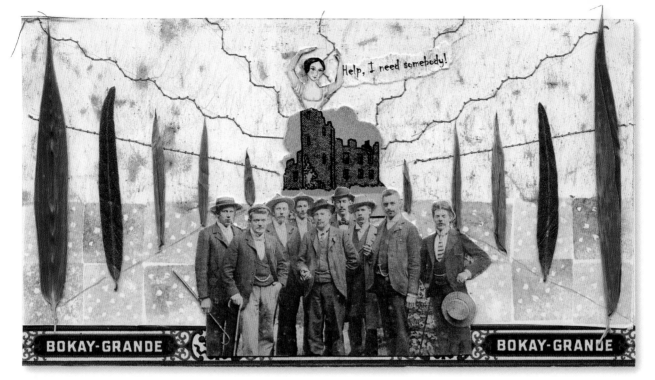

Simple Perspective

Also called linear perspective, this technique offers an easy way to create depth and perspective. Lay a horizontal line across the paper to serve as the horizon, mark its midpoint, and then let the other lines, fields, or strips meet at that point, also known as the vanishing point. Try to emphasize the perspective by placing the largest motifs or figures at the outermost points of the horizon line, and placing increasingly smaller figures closer to the center point.

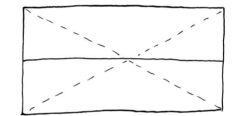

A postcard of the opera house in Paris was masked with tracing paper. The text and the musical annotation are from an old French magazine, and the tickets are from a 1940s travel scrapbook.

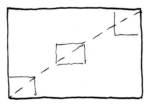

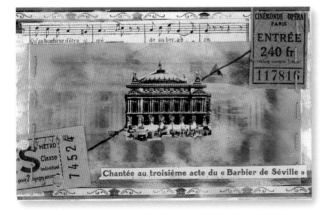

Diagonal Composition

In this technique, you place the principal elements diagonally across the surface, and balance the empty corners with less eye-catching pieces. The collage's expression may appear more dynamic when the diagonal line moves from the lower left corner to the upper right and more static when the diagonal line moves from the upper left to the lower right. A diagonal line can also serve to create balance, as in the collage to the left, where it connects three focal points.

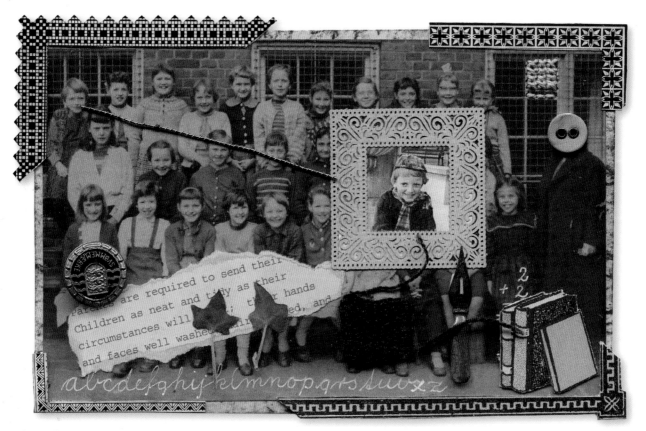

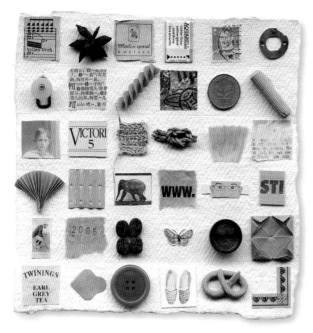

The Golden Mean

The golden mean is a mathematical construction based on an area that the eye naturally seeks on a rectangular surface with the specific proportions 1:1.618 (or 5 to 8). The eye is naturally inclined to settle on a point to the right and slightly above the center of any two-dimensional image (see the diagram at left), making this a good place for the focal point of a collage. If you'd like to delve deeper into the subject of the golden mean, it's described in innumerable places in print and online.

Catalog Composition

A collage with no center or focal point is like a little list. It isn't laid out to hold the eye or to let the gaze pause. It can be a thematic tableau based on a trip, a person, a memory, or, as in the collage to the left, based on a color, creating a kind of invitation to monotony that in itself can be fascinating. Or the collage can build on the reciprocal contrasts of the elements themselves.

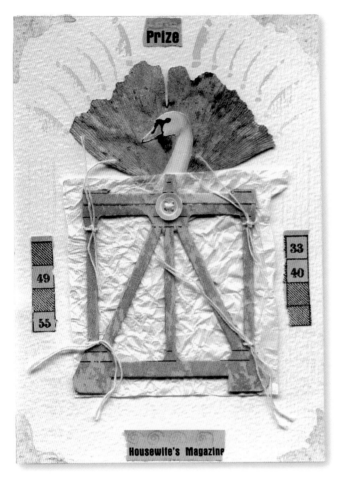

This collage started with a piece from a building set, a gingko leaf, and a piece of crumpled tissue paper.

Pyramid Composition

Used as the basic composition, a pyramid often creates a strong and collected expression, which can give a wild and gaudy collage some stability. An upside-down pyramid, on the other hand, creates a very delicate balance.

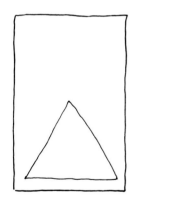

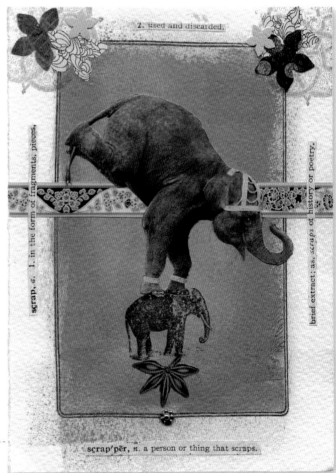

The idea of placing a large elephant on top of a smaller one inspired a visual representation of this impossible balancing act.

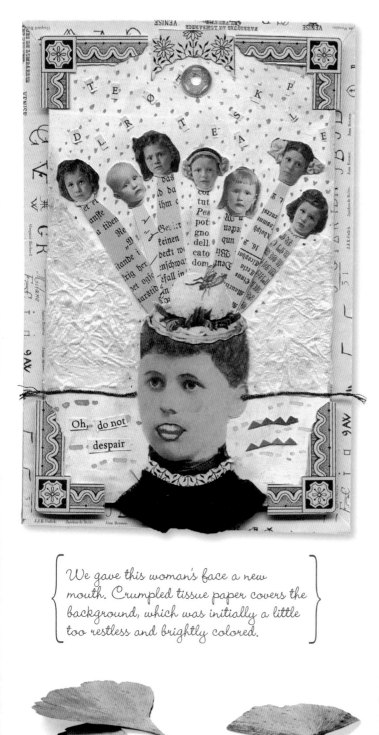

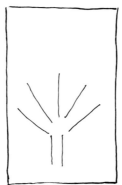

Tree/Fan/Flower Composition

For something a little different, start at the bottom center, and work upward and outward in a fan shape. This approach is similar in expression to the reverse pyramid construction. You can also try an upside-down fan.

We gave this woman's face a new mouth. Crumpled tissue paper covers the background, which was initially a little too restless and brightly colored.

Choose a Center Point—Anywhere! ---->

Choose any point on your collage for the center or focal point. Let it become the first point a viewer notices by giving it the most weight. To create harmony for the entire field of vision, balancing the rest of the collage to preserve the center point is important; this way, the composition won't "fall over." It's often surprising how little it takes to balance a composition. Just look at the collage on the facing page.

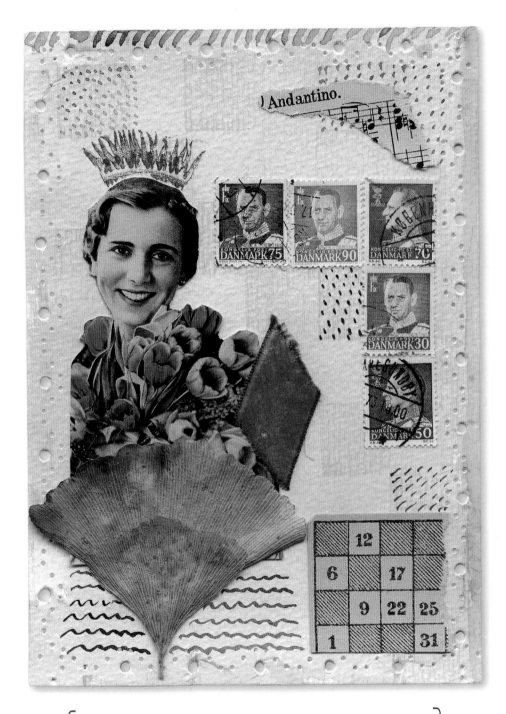

Here, the Danish queen, Ingrid, was placed in the "uncentered" center. Her image is balanced with postage stamps and part of an antique game board. We made the holes in the edges with a paper punch and a darning needle.

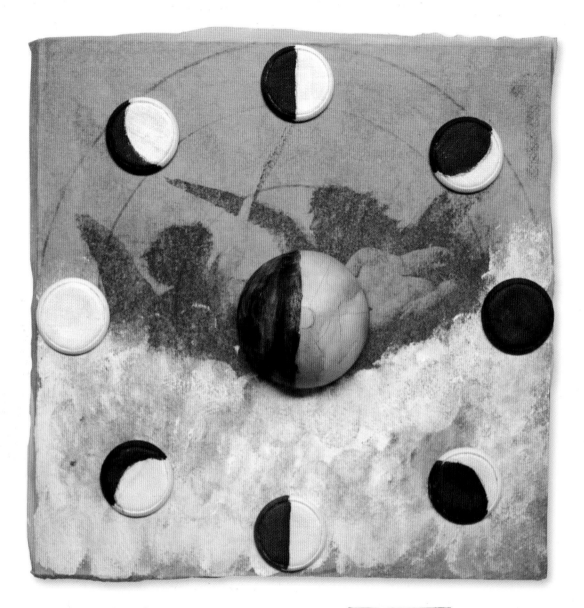

Circular Composition

The circle is a complete form, but it can also be dominating and absolute. It can often serve as a center point for your collage. Try making it lighter or heavier by barely suggesting it with a thin line, using a sheet of semitransparent paper laid over a background, or filling the shape out to the edge with images and color.

The Earth in this collage was created with a painted half ping-pong ball. The phases of the moon are buttons blacked with India ink. The background is a transferred angel motif with gouache clouds.

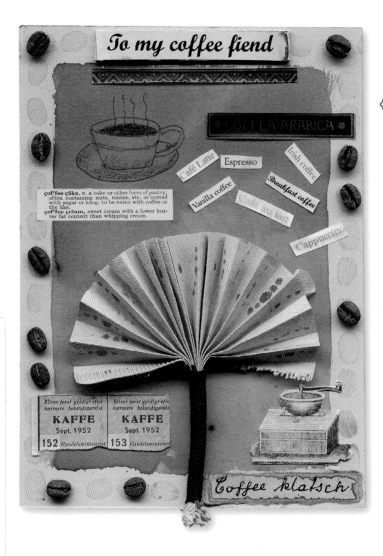

To my coffee fiend

COFFEA ARABICA

Café Latte Espresso Irish coffee

coffee-cake, *n.* a cake or other form of pastry, often containing nuts, raisins, etc. or coated with sugar or icing, to be eaten with coffee or the like.
coffee cream, sweet cream with a lower butter fat content than whipping cream.

Vanilla coffee Café au lait Breakfast coffee

Cappuccino

Bliver forst gyldigt efter nærmere bekendtgørelse
KAFFE
Sept. 1952
152 Handelsministeriet

Bliver forst gyldigt efter nærmere bekendtgørelse
KAFFE
Sept. 1952
153 Handelsministeriet

Coffee klatsch

{ We traced the cup onto cooking parchment with a soft pencil, and then retraced it on the back to transfer the pencil lines onto the paper underneath. The image comes out backward, but you can flip the motif before you trace it if you want it to transfer the right way. (See page 111.) }

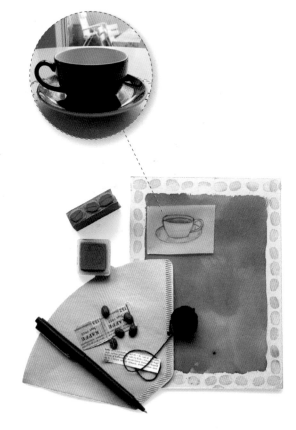

{ The photo in this collage was taken with a digital camera. With the aid of a computer program, we converted it to grayscale and then added brown tones. The final print was tinted with colored pencils. }

15¢ le chic
GUARANTEED WASHABLE

DETAIL AND GESTALT

A collage consists of details—some prominent, others subdued—but each can influence the overall piece. A couple of truly well-crafted details can work wonders. The viewer can feel all the energy poured into a single dot. A little embroidered French knot, for example, speaks more eloquently than a drawn dot—but it also demands more attention.

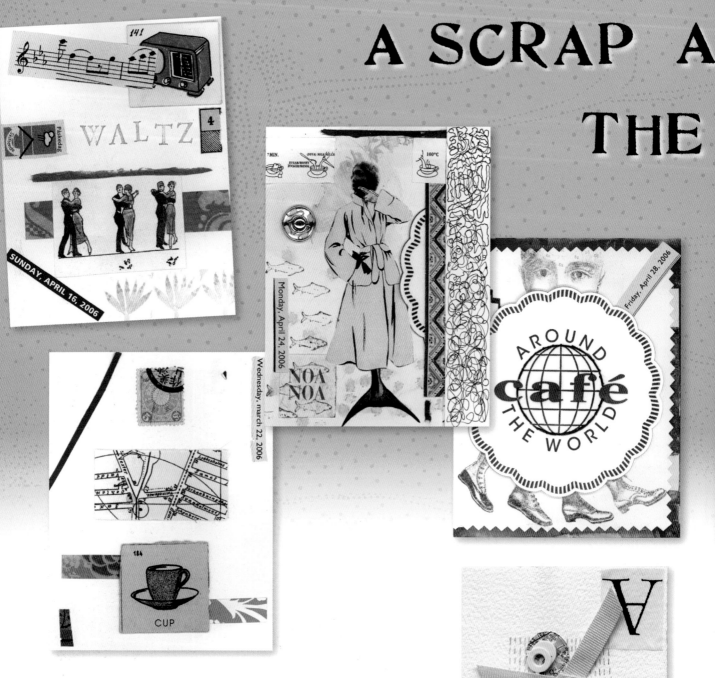

Spur-of-the-Moment Collages

These collages are seldom filled with meticulous detail, but instead draw life and strength from the dynamic energy and spontaneity that went into their creation. Spur-of-the-moment collages gain their power from lightness and impulse. They are often composed on the run—and their success frequently surprises the creator.

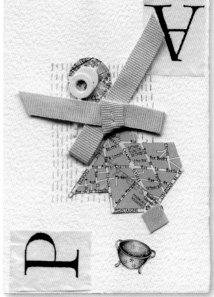

DAY KEEPS
DOCTOR AWAY

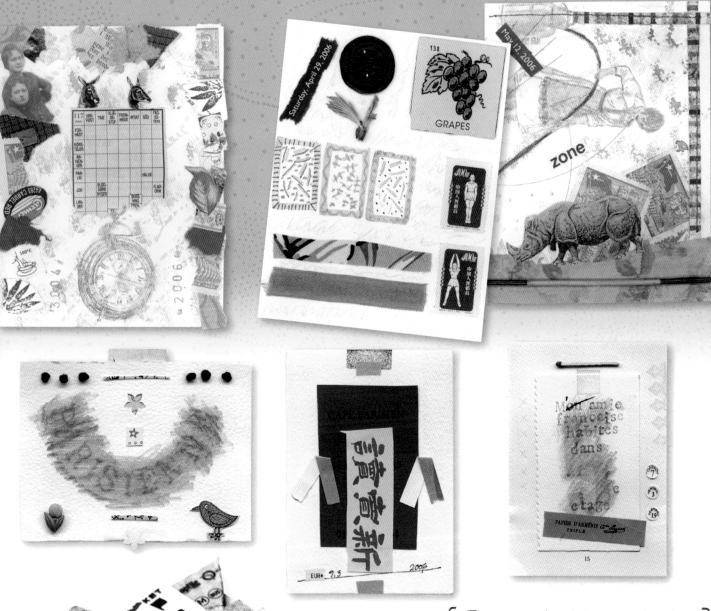

Scissors, a glue stick, a pencil, and an embroidery needle were stowed in one of our bags on a weekend trip to Paris. These items became the perfect tools for crafting a collage diary of the trip

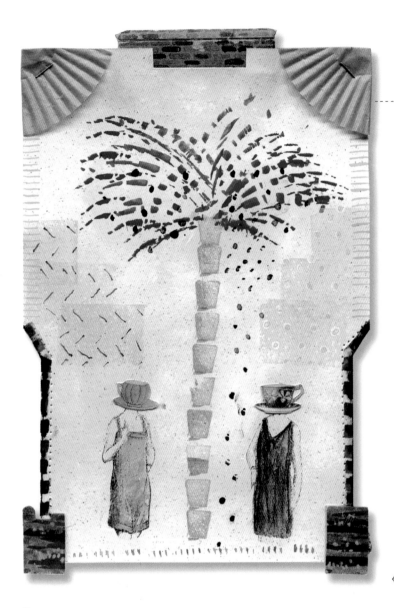

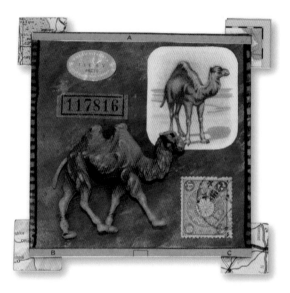

Here the contrast is surreal: two teacups with human bodies stand and converse.

The contrast here is between the painted image of a dromedary and a three-dimensional Bactrian camel.

The big "M"—created with a length of beaded wire and attached with hot glue—is used in contrast to the smaller elements around it.

Contrast

Contrast yields dynamism and excitement; you can create it through shapes, colors, materials, structures, surroundings, expressions, and messages. Try these simple oppositions: big/little, dark/light, soft/sharp, round/angular, new/old, original/copy, smooth/rough, raised/flat, organic/static, shrieking/sweet, handmade/manufactured, porous/solid, light/heavy, complementary/contrasting colors—and so forth. The use of contrast is one of the easiest ways to create surprise and to draw a smile from your viewer.

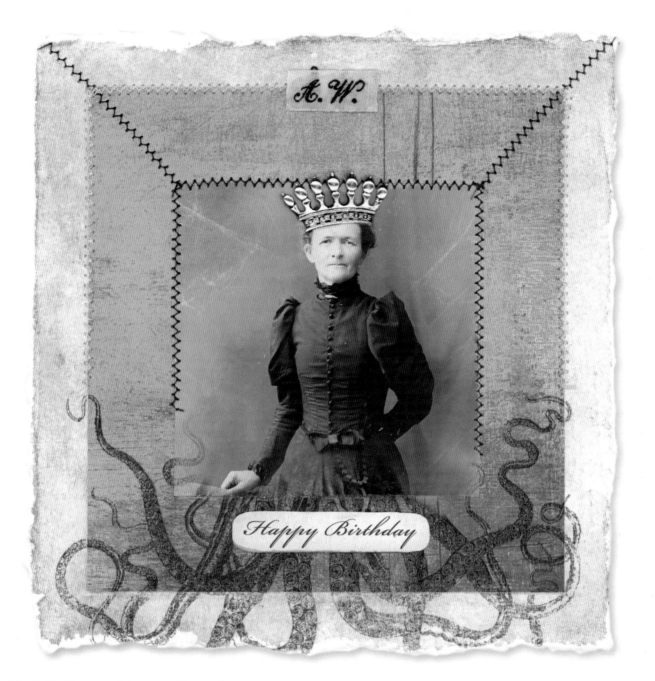

No Rule Comes without an Exception

Some rules can spur on creativity, and that's good, but just because something is regarded as a rule doesn't mean you have to stick to it. A rule merely points the way toward functionality. Once you feel confident, forget about balance points, and discover how to stand on your own two feet.

We photocopied this image and then crumpled it to create a worn look. We purchased the cotton paper, the red paper in the center, and the silver crown from a craft store. Using the transfer technique described on page 110, we added the black-and-white octopus. The small nametag at the top was a flea-market find.

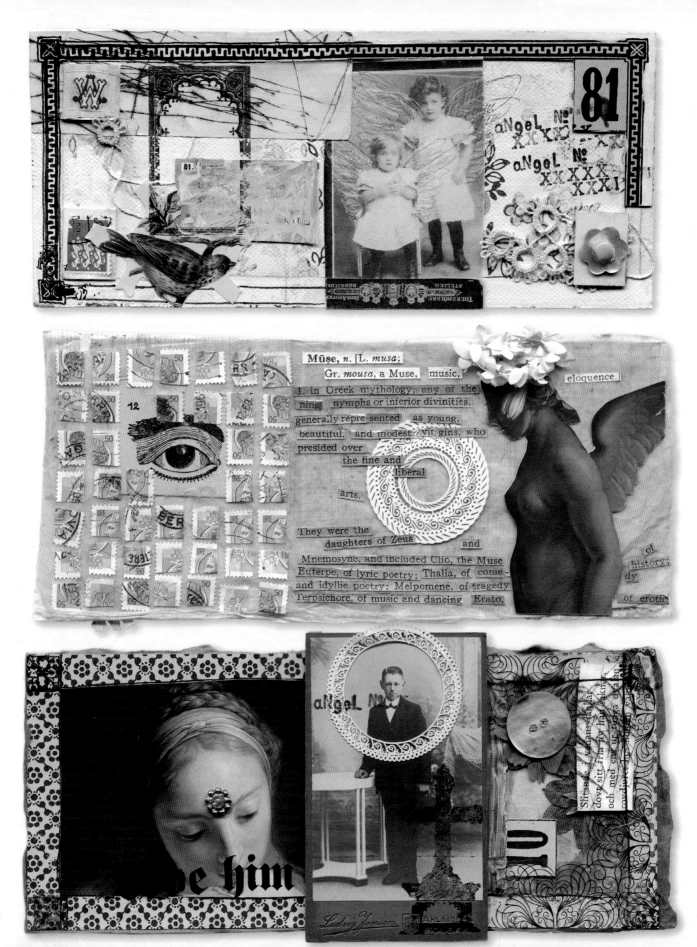

Freeing Your Inner Artist

BRINGING FORTH A PLEASING COLLAGE is pure happiness. Each collage can feel like a little miracle and will often inspire more collages, each made with different choices but just as exciting results.

As you become a little more experienced, you'll probably also become more critical of your own pieces. You may begin to make demands of yourself; you may feel that you always need to do your best work and that nothing is ever good enough. Self-criticism, indecision, and ambition block immediate and honest endeavor. Being *too* goal oriented is like looking into a funnel: your field of vision narrows, you overlook opportunities, and you think only of distant successes. When you cease to make unrealistic demands of yourself and focus instead on the unlimited possibilities before you, it's like looking *out* of a funnel: the field of vision widens, opportunities pop up, and suddenly the result is in your hands. Making demands of yourself and being self-critical aren't bad when you have a strong foundation of self-confidence, but if those demands turn depressing and negative, they can become fatal to creativity. Challenging yourself to do your best, to take time, and

to really be in the collage, on the other hand, will make the process more intense and close to you—and the result will be filled with life.

The collage process can test your patience. It may take a while for a piece to unfold itself and reveal all the available solutions, but give it time. You needn't grind to a halt just because one idea doesn't release the next in a flowing stream of great ideas. One solution is to look long and introspectively at the piece until your mind feels completely empty: spending quiet time with your collage can work miracles. You can also make a list of your supplies and try various new elements. Pair non-matching, different, and unrelated fragments to see if an unexpected effect is hidden in them. But try to avoid the trap of thinking your way out. The most surprising solutions often appear when you forget to think and begin, instead, to work intuitively. Try experimenting by moving elements around. You may discover something unexpected and exciting, or the suggestion of a story may appear, taking form according to who is interpreting it. When you're experimenting is often when you create truly eccentric and unique art.

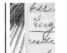

TWO STEPS FORWARD, ONE STEP BACK

Now and then, a collage gets stuck, and no matter how hard you try, you just can't get it going again. Our best advice is to take a break from the piece until it returns to your good graces. Distancing yourself from a collage that's teasing you can be very fruitful, as can having a number of collages going at the same time. When you look with fresh eyes at the same collage again after a few hours or even a few days, the solution will sometimes appear on its own. When it doesn't, at the very least, you can often see where the collage has gone wrong.

KILL YOUR DARLINGS

It's easy to fall in love with a particular type of element, but that element may end up sneaking itself into every collage you make. If it doesn't really fit in the collage you're working on, you have to let it go. Remember that it's the *gestalt*—the whole—that must function. Sometimes you even have to give up the original idea, turn it around, and start over from the beginning.

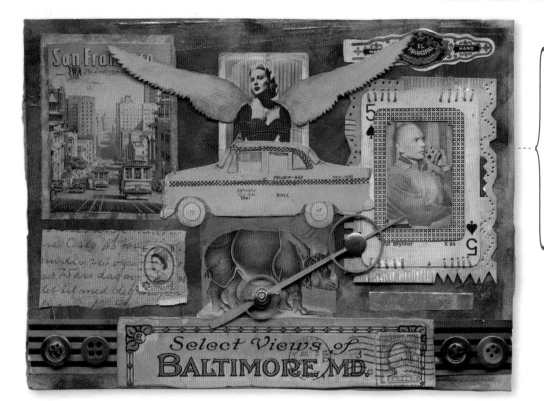

The card with Yul Brynner is new, the antique clock hands are from a flea market, and the other items are inherited or from the artist's own stash. To pull the composition together somewhat, the whole work was shellacked.

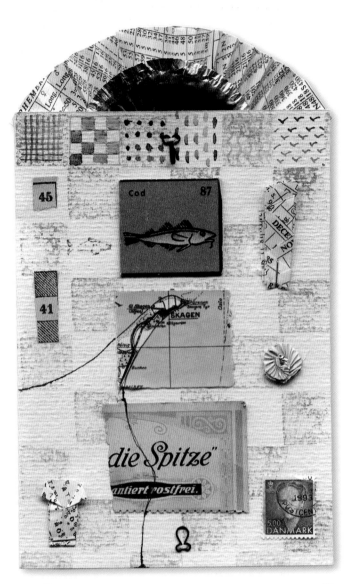

WHEN IS A COLLAGE FINISHED?

At some point the collage will be finished, so you should practice knowing when to stop. You'll often come to the point where you think it's *almost* finished, but there's just one weak area or something missing that catches your eye. It might be one spot or dot that seems tame or bare; it could be that the whole thing leans to one side; or it may be something else entirely. But as a rule, when that problem is solved, the collage is finished. Sometimes it's almost as if the collage speaks up and says, "I'm done!"

It's also possible that you won't have that one indefinable element needed to finish the piece, so you overdo it. The addition becomes too big, so you try to fix the damage by embroidering a knot in the opposite corner and snipping a notch in the edge. Before you know it, you've ruined the whole collage—the one that seemed so promising. And if you're really unlucky, it will be the collage that features the original photograph of late Uncle Albert!

If you can't erase or cover the damage—and the first-aid tips on page 74 don't help—you may have to take a deep breath and accept the fact that you're one experience richer. But remember to rescue the elements that can be reused.

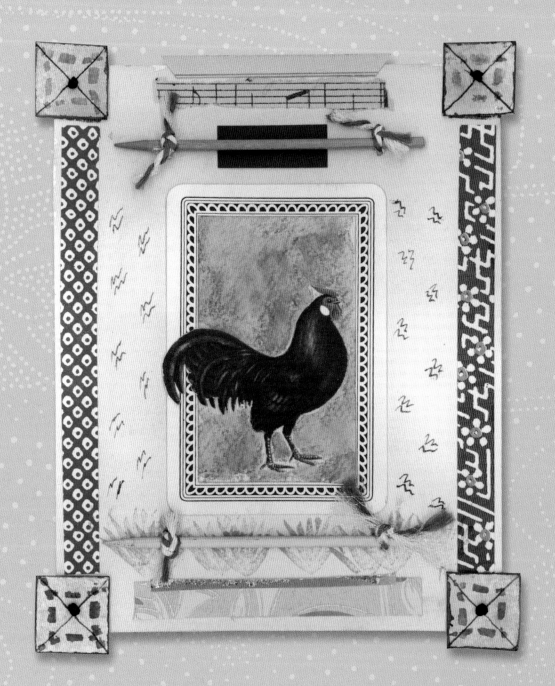

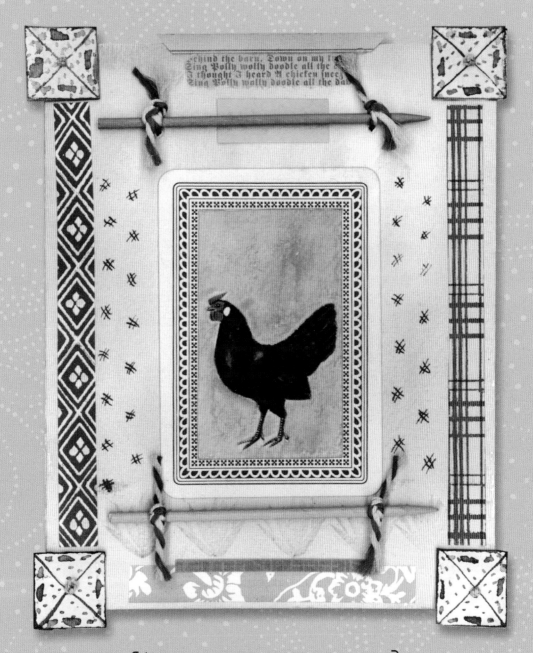

The hen and the rooster were mounted
in frames made from playing cards,
allowing the two collages to complement
each other perfectly.

FIRST AID FOR COLLAGES IN DISTRESS

Now and then, a mistake leads to a new and exciting idea or method. Here are a couple of suggestions for ways you can try to recover a doomed collage.

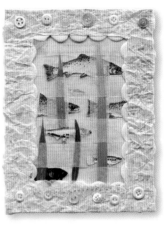

- Cover the problematic area with effect paper. The paper can be lightly transparent—crumpled tracing, tissue, or waxed paper, cake pan liners, cooking parchment, and bandaging gauze all work well.
- Cut out the offending area completely and insert another background.
- Create holes in the area and embroider over the problem.
- Paste a picture, motif, or something else over it.
- Paint over the area with gouache and start over.

The catalog collage below became an inspiration for the sewing collage on the facing page.

CRISES

If those ideas techniques don't help and you begin to feel really stuck, you may become seized by wild delusions: your collage career is over, you've used up all your resources, and you'll never, ever be able to put two things together again.

When you throw yourself into a new medium, reaching a point at which you feel that all your creativity has been expended is typical. You may find yourself saying, "That's it!" and even contemplate closing up shop. If this happens to you, it's only a sign of exhaustion and a passing lack of confidence. Go knit something, watch TV, read, wash the dishes, go for a walk, take a nap, or go have coffee with a friend; then start your work again when the desire—or the desire for the desire—comes to you. Accept that you're in a dormant period during which, without anyone noticing, you're stocking up for the future.

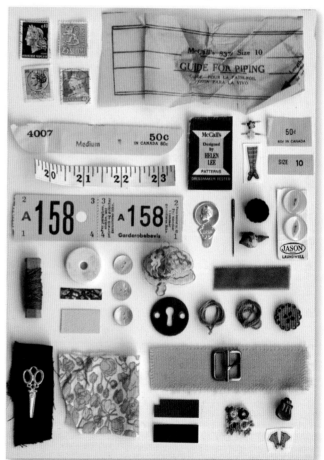

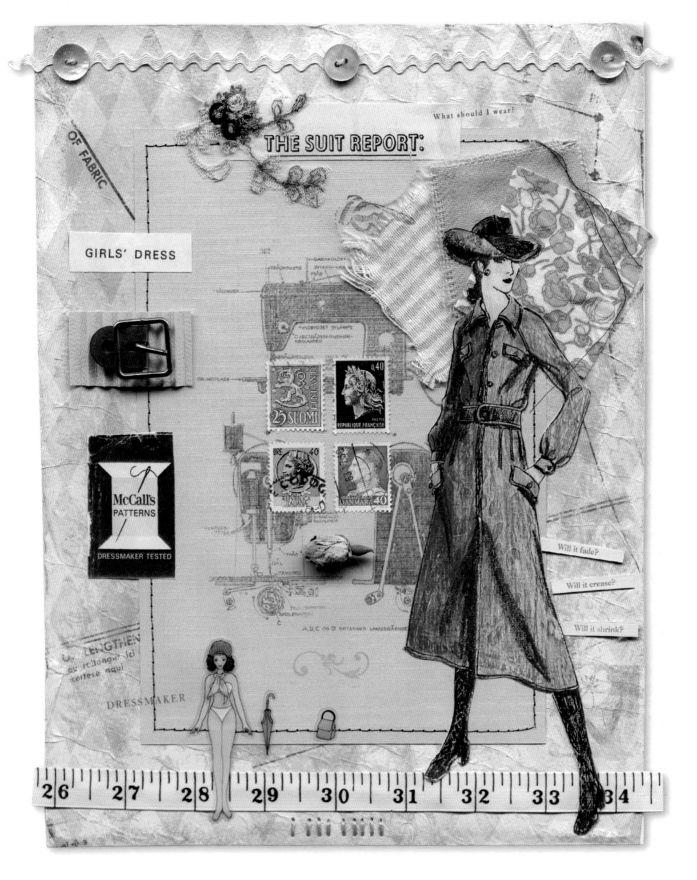

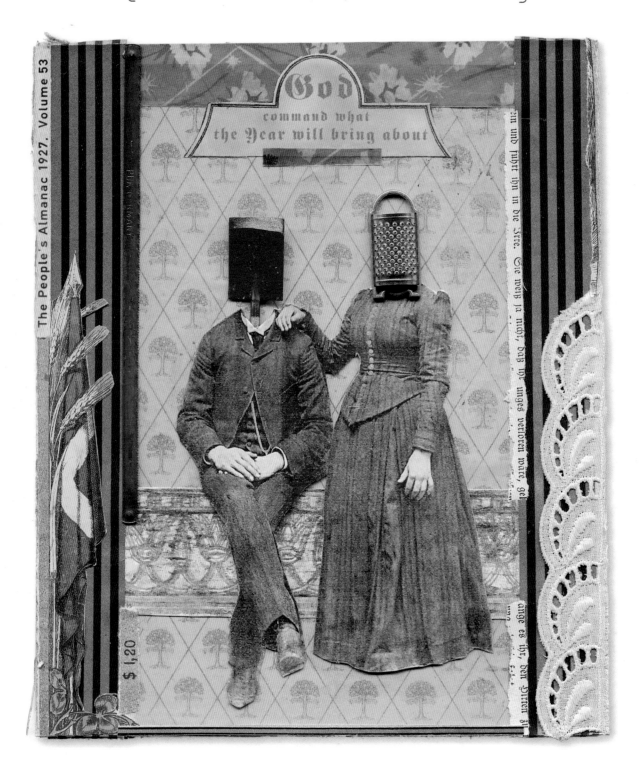

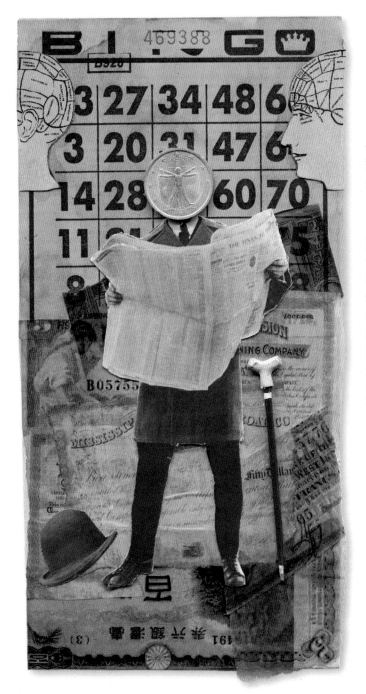

Here is some criticism you risk hearing in your head:

"My collages are always so—pretty and predictable—wild and untidy—unfinished—entirely too simple and bare—half-dead and lacking in vitality—so tame and flat—confusing and scattered—chaotic—boring."

If you've put a label on your discontent, you've also pointed a finger in the direction you can move to make a change. If you're tired of clinging to the cute and the darling, try making an *ugly* collage. If you think your work is too simple, paste on gobs of elements. If you feel tame and flat, take a chance with contrast. Is your work confused and scattered? Make a collage that is systematically built upon a theme. You can even use one or two of the most prominent elements from the poor little collage that you disliked. No matter what, try the exact opposite—not because your style has to make a 180° change, but because doing so can free you from confining habits.

Another way out of the icy grip of habit is to allow yourself a little inspiration—either from great classic artists or other mixed media artists. Search "collage" online to take a cyberspace tour that will reveal how others express themselves in your medium, which can be a truly motivating experience. Such a sightseeing trip can even end with the realization that the tendencies you saw as weaknesses are really strengths.

A paper napkin and diverse bits of
paper form the background for my
mother's sister, who has become a rose.

Mr. Penhead on an
old airmail letter

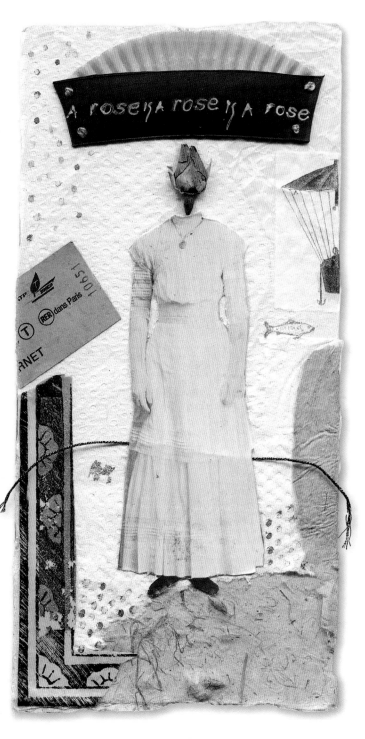

{ Stamped letters and a handmade pattern decorate a page from an old book. The figure is the same as that on page 80, just blown up and with a walnut head. }

{ The transferred eye and skeleton are from an anatomy book. The fox-fur-embellished dress is from a family album. }

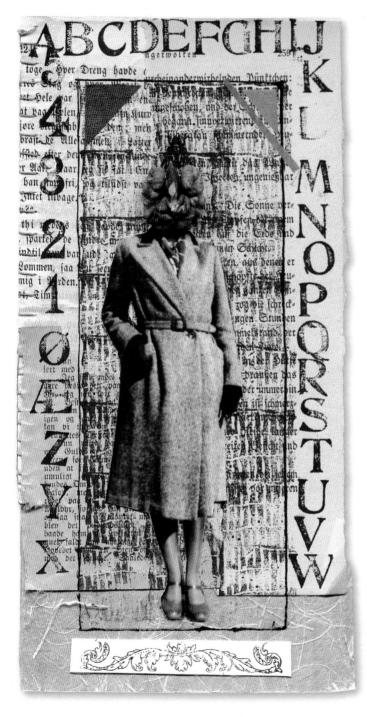

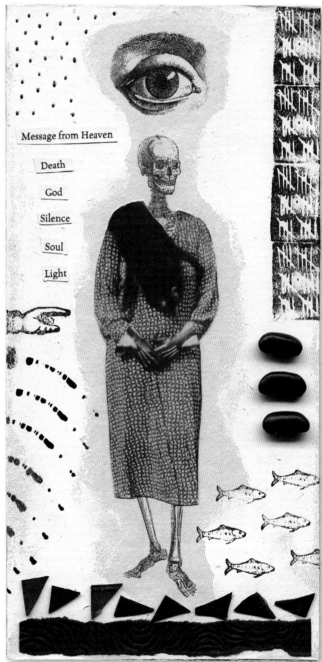

Message from Heaven

Death

God

Silence

Soul

Light

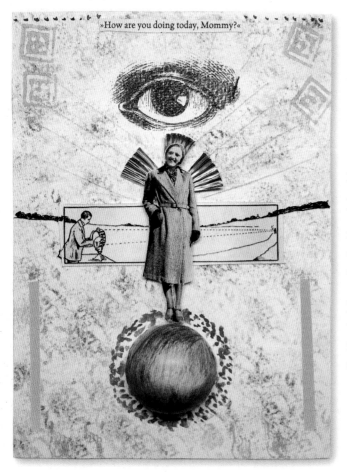

»How are you doing today, Mommy?«

CREATIVE COMPETITION

We can all be struck by an acute feeling of angst about our ability when we see another artist's collage that we think is way beyond the ordinary. Accept this as a passing feeling, and don't let it become a long-term block. Take it as a challenge and a push to improve your own work, finding happiness in the fact that the work calls forth an expression you admire. Imagine that the seductive collage has been through a painstaking process, and that its creator may be a gifted mixed media artist with years of experience, who has, at one time or another, suffered from a bit of anguish.

Try to figure out what it is in particular about the collage that has made you fall for it so hard. What effects—what energy—in it impress you? Learn to use the same feelings in your own way and, through those feelings, create your own mood.

INSPIRATION OR PLAGIARISM

What's the difference between being inspired by something and plagiarizing it? As we interpret it, inspiration is when you see something that gives you a desire to create something of your own. It's an intense experience—activating something inside of you that now demands to be heard and expressed. When dealing with a direct inspiration, the starting point may be in the idea, the basic expression, or the mood, but once you're underway, the important thing is not to bind yourself to the source that inspired you.

Tear loose and let your own creativity come out to play. If you're bound to the source of your inspiration—clinging to the idea that your own work must be an accurate copy of it—you've overlooked an opportunity to express yourself. But if you're not used to expressing yourself visually, trusting your own abilities can be hard, so copying may be an acceptable way to get started.

And the next time you sit down to work, you'll have a little more courage to cut loose from the safety of the shore.

{ The personal equivalent of a business card, the calling cards on the opposite page were inspired by a hand-written card from a shop in Florence, Italy. }

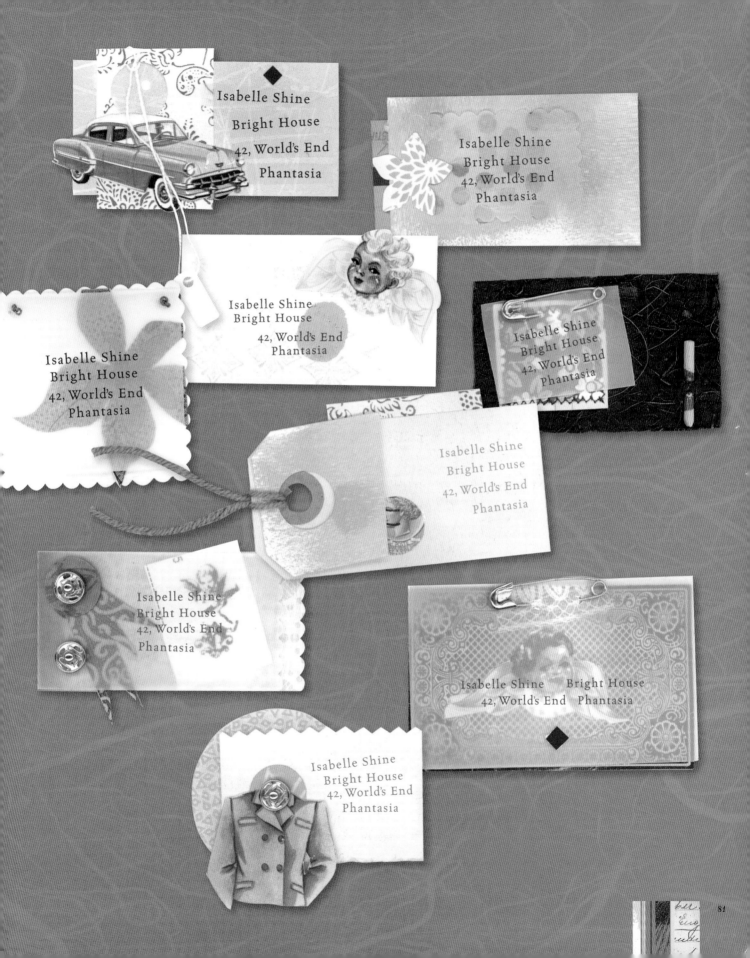

Isabelle Shine
Bright House
42, World's End
Phantasia

Isabelle Shine
Bright House
42, World's End
Phantasia

Isabelle Shine
Bright House
42, World's End
Phantasia

Isabelle Shine
Bright House
42, World's End
Phantasia

Isabelle Shine
Bright House
42, World's End
Phantasia

Isabelle Shine
Bright House
42, World's End
Phantasia

Isabelle Shine
Bright House
42, World's End
Phantasia

Isabelle Shine
Bright House
42, World's End
Phantasia

Isabelle Shine Bright House
42, World's End Phantasia

Isabelle Shine
Bright House
42, World's End
Phantasia

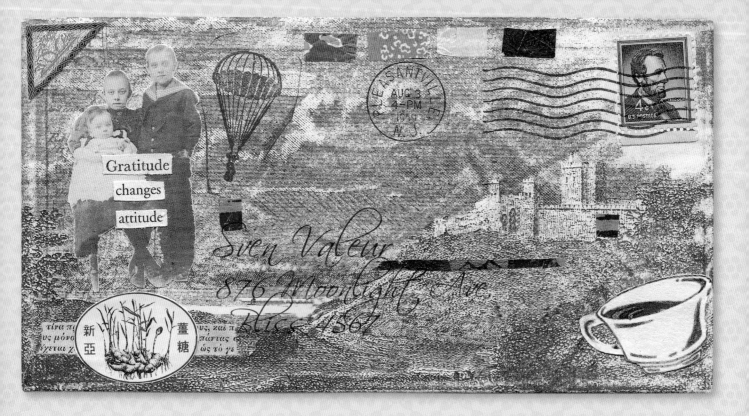

Gratitude
changes
attitude

Sven Valeur
876 Moonlight Ave
Bliss 1867

新亞 薑糖

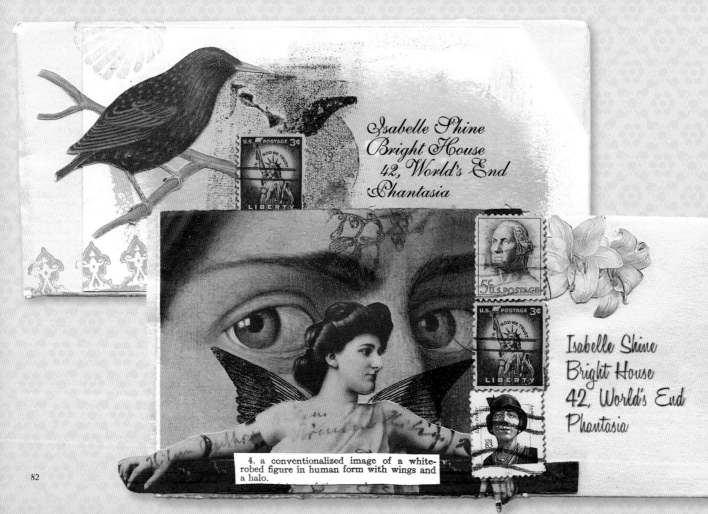

Isabelle Shine
Bright House
42, World's End
Phantasia

Isabelle Shine
Bright House
42, World's End
Phantasia

4. a conventionalized image of a white-robed figure in human form with wings and a halo.

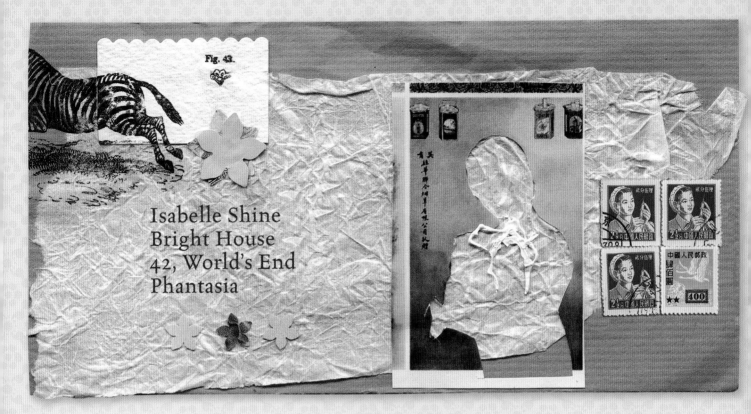

Isabelle Shine
Bright House
42, World's End
Phantasia

On these personalized, richly decorated envelopes, the stamps have both a function and a decorative effect.

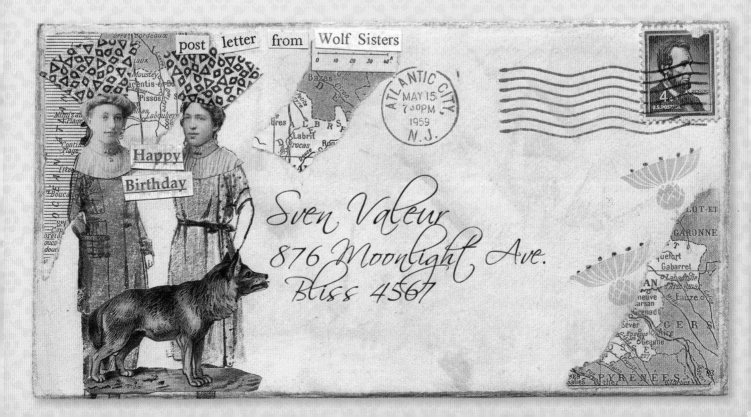

post letter from Wolf Sisters

Happy
Birthday

Sven Valeur
876 Moonlight Ave.
Bliss 4567

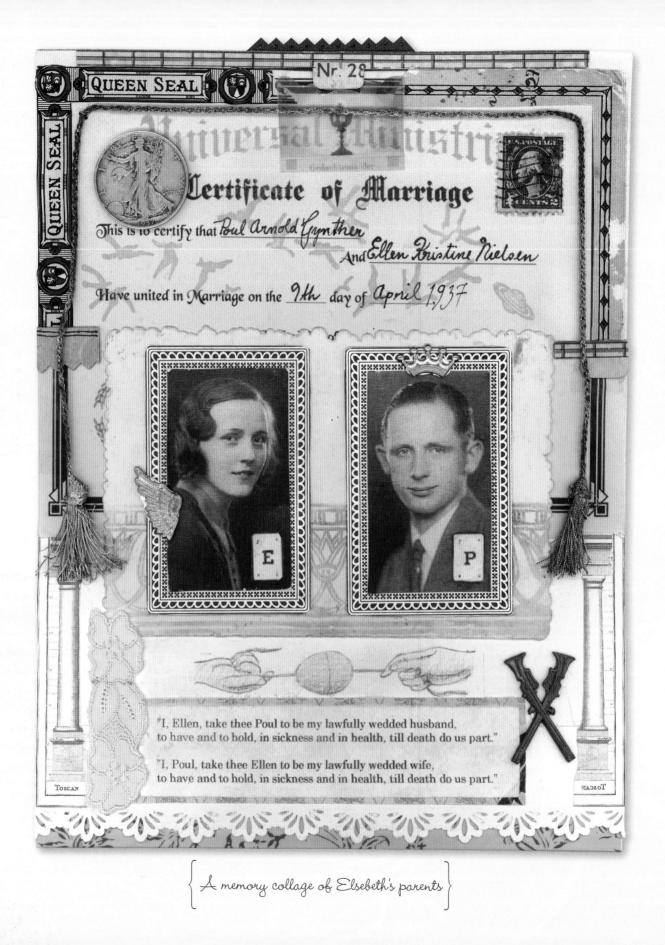

{ A memory collage of Elsebeth's parents }

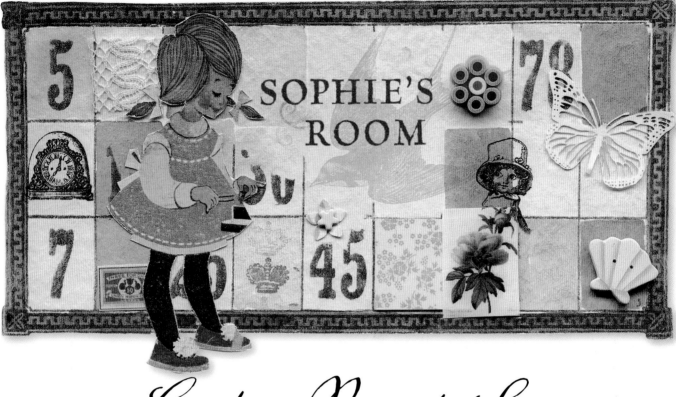

Creating Room to Scrap

WHERE THERE'S A WILL, there's a way…to collage. Do you prefer to work alone, or do you enjoy the life of your household swirling around you? Before you decide where to assemble your collages, answering these questions is helpful.

If space is tight and you have no option for a set place to work, you can make a mobile studio with a portable storage system. Stock a large, portable tray or bin with collage materials and tools so you can set up and work in the family room, the kitchen, the summer home, or wherever you need or want to.

If you have a worktable or an entire room to yourself, it's probably used for other activities as well, so organizing your materials and tools is a good idea regardless. We've organized ourselves differently.

Elsebeth's setup: She has a workroom with a worktable, shelves, bookcases, and an old drawer system from a car repair shop, which works perfectly for storage and organization of everything from paper to flea-market finds.

Christine's setup: She works in a corner of the living room. A table—once used to display knickknacks and family photos—is now covered with a cutting pad and a good table lamp. She keeps her materials loosely (un)organized in a little storage tower of drawers. When the room has to be straightened up for formal use, the tower and periodical holders move into a closet, and the table is cleaned up.

The advantages of a large workspace seem obvious since the risk for mess and losing things is much greater than when you're forced to work in a small area.

CHAOS VERSUS ORDER

If you can't find your treasures, you'll get very little use out of them. Of course, tripping over something you'd forgotten about is lovely, but consider the frustration and the time wasted when you have to look—and look—for that special item you know you have.

Construct a system that's logical for your way of remembering things and thinking. It's totally up to you whether to sort things according to the material they're made of, by theme, or in some other way entirely. No matter what your sorting method is, some things will fall between the cracks of your system, so it pays to have a miscellaneous pile as well. A couple of ring binders with plastic pockets for papers and other flat items, a table cabinet with drawers, various boxes, chests, and plastic boxes with dividers are all functional archiving systems. Another method is to use a clothesline: put your items in plastic slip jackets or sandwich bags and hang them on the line with clothespins so your whole collection stays in sight. Having tools, materials, paints, and everything you need within reach when you work is a great advantage. Using various techniques is far more convenient when everything is close at hand and tempting you than when you have to think about what you have and need, and then dig it out.

If you're in the midst of working on a number of collages at once—even if some are still in the gathering stage—keep them in plain view so that you're always aware of their existence. Little by little, collect the things you need, keeping everything organized.

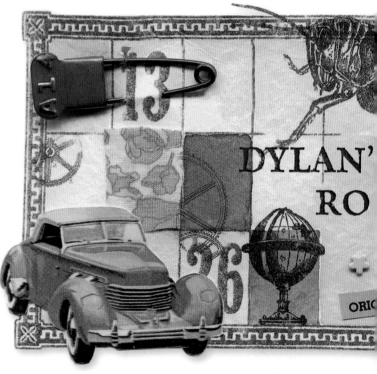

BUILDING YOUR TOOL KIT

You can go far in collage with just a pair of scissors and a glue stick, but you'll start to demand more of your tool kit as you become more experienced and experiment more. The tools shown below are in the basic kit we use ourselves and are perfect for taking care of most needs. You can find more detailed information in the next section.

There are many ingenious tools on the market, and it's easy to be tempted by them. Getting new tools goes along with the desire to explore new techniques. Building up your tool kit little by little allows you to become familiar gradually with what these new tools can do.

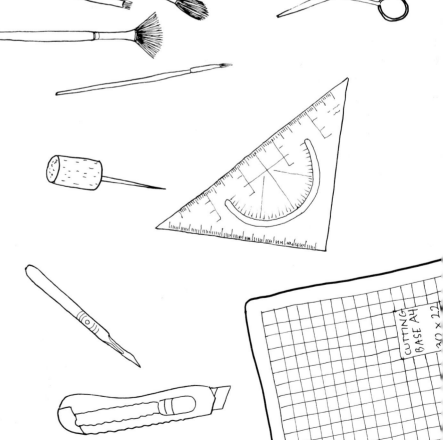

{Sign for the door of a boy's room}

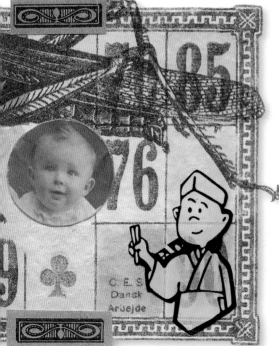

Working with Paper

COLOR

Most people with an interest in art own a variety of paints and coloring tools. Our recommendation is to begin with what you have, gradually building up your supply as your need grows.

Colored pencils, oil pastels, and crayons are among the most popular and usable dry colors. If you use "wet colors," we recommend water-based paints such as gouache, acrylic, or watercolors. Other kinds of liquid paint work well, as do India inks. Paints are available in many qualities and range in price, with the most expensive generally described as "color-fast." These tend to tolerate light better without fading—when a collage is hung on a sunlit wall, for example—than the less expensive paints. Where you want to place yourself on the price scale is an individual choice, but be aware that the most expensive paint isn't necessarily the best for your particular project. You don't want to commit the classic error of buying wonderful, expensive paint that you don't have the heart to use.

Each of us has a fine little box of expensive watercolors, another box with 24 colors, and a reasonably priced box of gouache paints that we use all the time.

For paints and other mediums, it's best to clean your brushes and tools immediately after you use them.

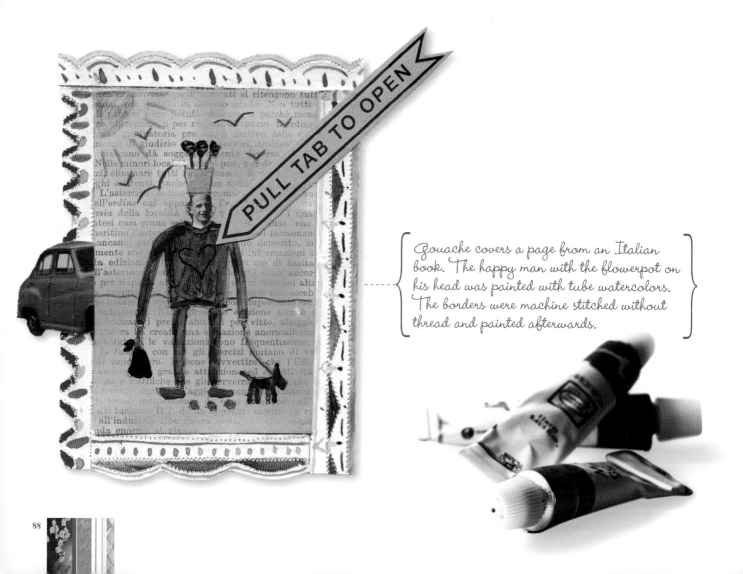

PULL TAB TO OPEN

Gouache covers a page from an Italian book. The happy man with the flowerpot on his head was painted with tube watercolors. The borders were machine stitched without thread and painted afterwards.

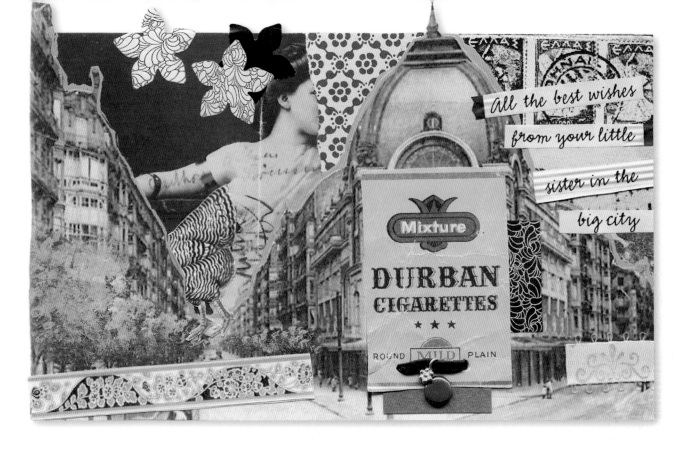

Colored pencils. These aren't as inexpensive to use as you might think. The cheapest ones break easily, so investing in higher-quality pencils, which are available in a variety of colors and tones, may be a good idea. Also available are watercolor pencils, the colors of which can be brushed with water after they're applied to increase the density and consistency.

Oil pastels, pastels, and other crayons are good for creating effects on most surfaces. Shade the color by rubbing it with your fingers, or use the side of the crayon to get a consistent, blurry coverage.

Gouache. Water-based and completely opaque, this paint can be applied with a brush, a roller, fingers—basically in any way you want. It's easy to work with.

Watercolors can be purchased in tubes and cakes. The latter are the easiest to work with and last the longest. Watercolors are easy to mix, and can be thinned with water to obtain very light and delicate nuances, but keep in mind that your paper must be able to tolerate getting wet. Two to three good watercolor brushes give better service than a whole handful of lower-quality ones. Treat your brushes well and rinse them after each use to prolong their lives.

Acrylic paint is water based and available in many qualities. Also called "hobby" or "craft" paint, it's versatile in that it adheres well to most surfaces, provided they're not too smooth or too greasy.

Acrylic can be used straight or thinned with water for a transparent cover. The colors are easy to mix and dry quickly, becoming waterproof. Acrylics are available in small and large tubes, jars, and bottles.

Liquid watercolors and airbrush paints are fluid, colorfast, and clear. Both are easy to mix, can be applied with a pen or brush, and come in many colors.

India ink and other inks are more viscous and crust very quickly. In addition to India ink, you might try traditional and Chinese inks.

SCAN, PRINT, AND PHOTOCOPY

Using pictures is inevitable when it comes to collages. If you use digital photos or are timid about using your own pictures, it's good to have a scanner, a color (laser) printer, or a photocopy machine on hand.

New computers sometimes include scanning capabilities and some form of photo-editing software. It's relatively simple to scan photographs, drawings, and other illustrations, which can then be adjusted in color and size, flipped, etc.

Setting up a folder with illustration material in case you want to reuse an illustration is a good idea.

If you must leave the house to make copies, you'll find that the paper most copy-center machines use is smooth and coldly white. However, many copy centers offer a wide assortment of different colors and thicknesses. You might try bringing along your own paper for the copy machine. This way, you can better control what is expressed in your

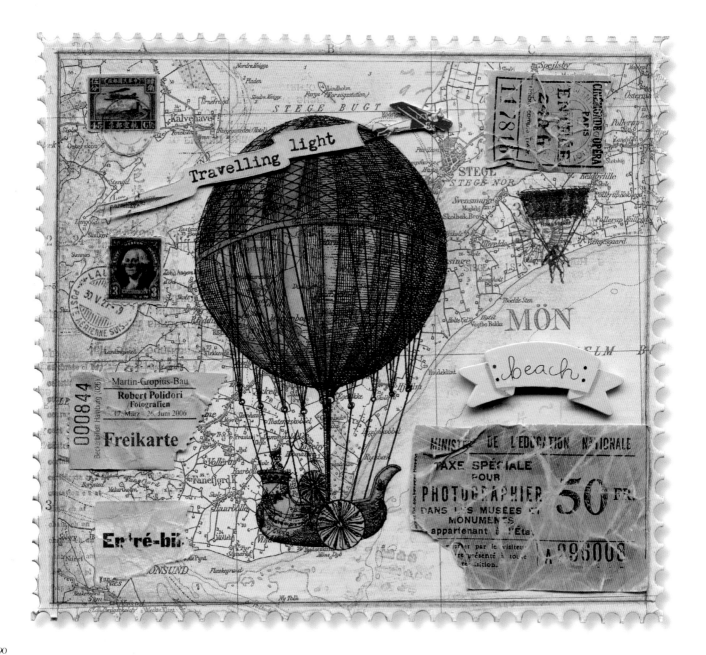

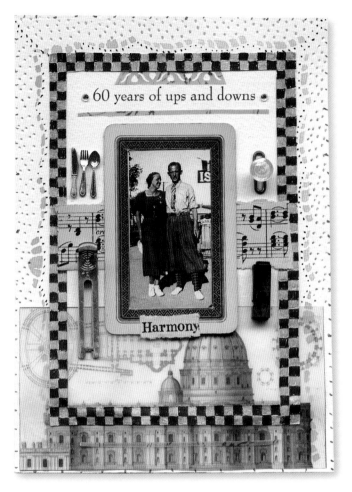

60 years of ups and downs

Harmony

copies. For instance, if you're copying the original photo of Uncle Albert, try using a piece of thick watercolor paper or a piece of unbleached white or cream paper in the machine. Uncle Albert will have a softer and more antique look, and you'll have more leeway for working with the image later.

When you put special paper in the printer, be aware of its weight. If you've brought your own paper to a copy center, check first to make sure it will work in the machines to avoid jams. Ordinary copy paper is 80 grams, but most printers can take a heavier weight. A variety of paper weights/thicknesses are available in a range of colors from craft stores, art supply stores, and paper suppliers. Other possibilities include tracing paper—making it possible for you to create your own vellum (colored or decorated semi-translucent paper)—airmail letter paper, sheet music paper, technical drawing paper, and printed papers. These don't have to be 8½ x 11 inches (21.6 x 27.9 cm) since most printers can be set for smaller formats, but don't forget to adjust the printer's copy and paper preferences. If necessary, do a test run, printing on a piece of photocopy paper with the black-and-white setting so you don't waste an expensive piece of paper.

This diamond anniversary greeting card features a photo of a couple in their youth. The button, hair clip, and letterpress type are from their own collection. Accented with imagery inspired by the couple's favorite city—Rome—the checkered frame was hand-colored in black and gold.

A map was copied onto a sheet of unbleached paper. The balloon was then copied onto the map and tinted with watercolors. The additional ephemera were pasted to the collage, and the edge was made with an ordinary hole punch.

STAMPING

When you first start working with stamps, it may feel a bit mechanical. That feeling soon goes away as you discover the decorative possibilities and the results you can achieve using stamps. It's a fun technique with unsuspected opportunities to create exciting effects. There are many ways to get stamps, but you can also make them yourself.

Manufactured Stamps

You can find any number of manufactured stamps in craft stores and online. There are even specialty stamp stores, and the number of online stamp shops seems to be infinite—just try looking up "stamps" or "stamping" with your search engine.

Wherever you look, you can find just about every imaginable motif and quality. Some come as unmounted pieces of rubber; others come with handsomely manufactured handles. These are relatively expensive, especially considering that you may want to use each one only a limited number of times.

You may also be fortunate enough to stumble upon vintage metal stamps, typographic printing plates, or letterpress type. Put a soft padding under your surface, and use the plates or type as stamps.

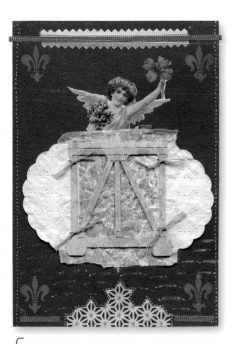

{ The object featured on page 59 has been used a little differently here. }

{ A box from a newly purchased music stand was the starting point for this little collage. The stamp for the small keyboard was cut into an eraser, and the dots on the keyboard were found in the reservoir of a hole punch. }

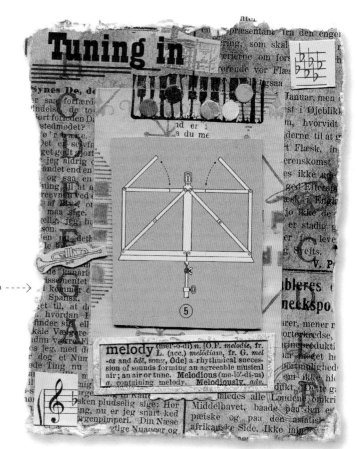

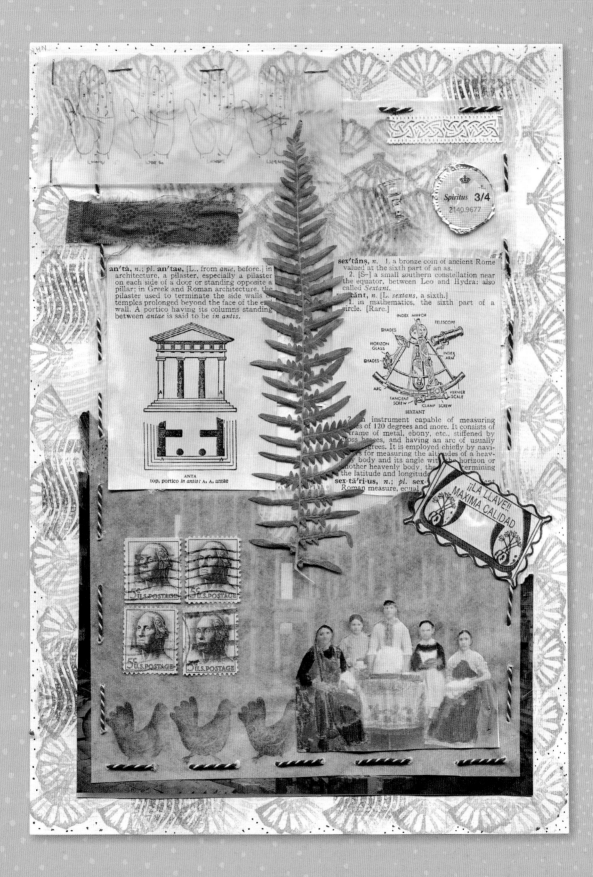

Natural Stamps

Take an exploratory mission to your local grocery store; you'll be surprised by how many handsome patterns are hidden in fruits and vegetables. The most immediately useful are the drier vegetables—those that don't drip juice when you cut into them—such as okra, mushrooms, Brussels sprouts, whole cabbages, leeks, lemongrass, broccoli, parsnips, raisins, baby corn, and more. Be sure to slice them so the cut surface is as flat as possible.

You can also use the less dry options, such as kumquats, apples, pears, squash, cucumbers, and onions. Just try to blot the cut surface dry on a paper towel before applying color; otherwise your color will be diluted by the juice, and your stamp pad may become sticky.

The background pattern on this page was made with the small crosscut apple shown on the opposite page. Ink was applied to the center of the apple (not out to the edge).

Leaves are another of nature's kind gifts that make very fine prints. For example, glue a leaf, with its back side up, onto a large eraser, and cut the eraser, following the shape of the leaf.

And let's not forget the good, old-fashioned potato print. The potato is just fine for stamping; simply cut into the flat surface to create a design.

A fourth natural stamp, which is always right at hand, is your fingerprint, but why not try using other parts of your body? Your hands, toes, heels, feet, elbows, or ears would all make wonderful stamps, but if you find yourself falling so in love with this technique that you want to kiss your collage, we recommend using lipstick as your stamping ink.

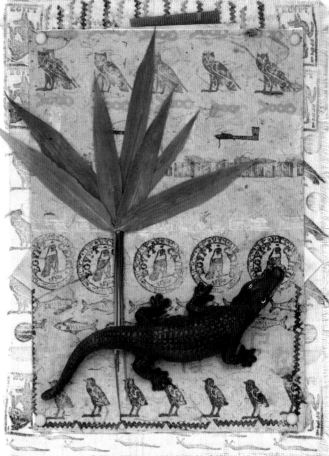

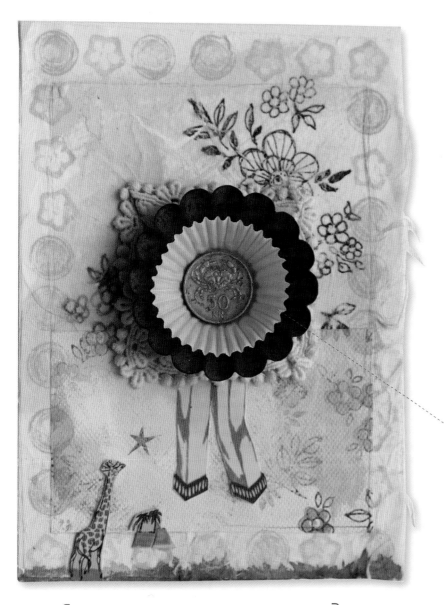

{ The border and the examples above were made with a cross-section of lemongrass, a cross-section of okra, and a stamp pad. }

{ The metal sweets mold on this collage was a flea-market find. This piece is intended as a little accent for a child's room. }

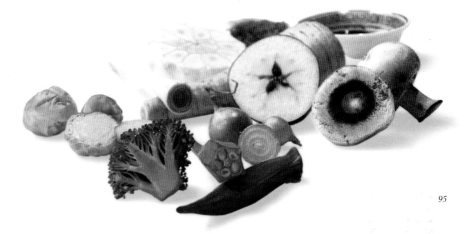

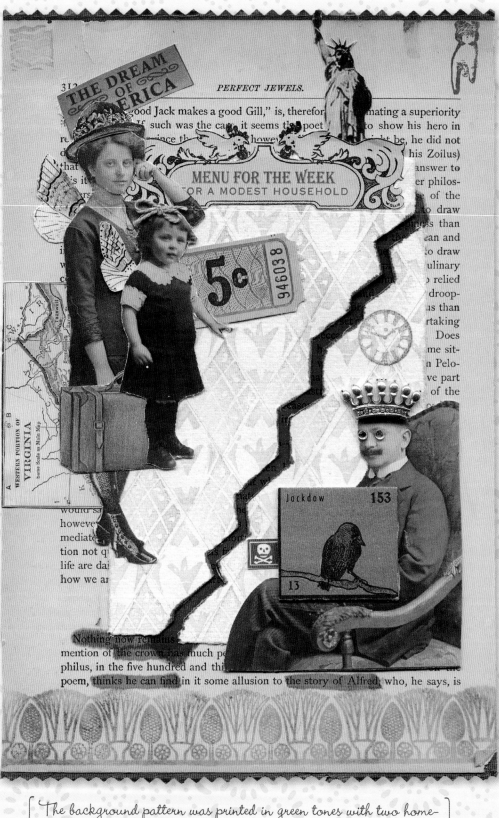

THE DREAM OF AMERICA

PERFECT JEWELS.

MENU FOR THE WEEK
FOR A MODEST HOUSEHOLD

5c

946038

WESTERN PORTION OF VIRGINIA

Jackdaw 153

13

{ The background pattern was printed in green tones with two home-
made stamps. The two adults were originally from the same photo,
which was the starting point; the story emerged little by little. }

Homemade Stamps

If you can't find exactly what you want, you can cut your own stamp. Cork and rubber, which—when translated into everyday language and materials—mean wine corks and erasers, are the most suitable materials. Erasers are available in innumerable shapes, qualities, and prices. For making stamps, our experience is that somewhat waxy erasers often shed little crumbly bits; tight, hard erasers are well suited for fine, thin lines; and the softer kind is good for pattern blocks and softer shapes. Try experimenting with each one.

If you want a particular motif, draw the shape or pattern on the eraser and cut it out using a linoleum knife, a scalpel, a small utility knife, or maybe even a strong darning needle. Linoleum knives, being most versatile, are available in sets, with a handle and five or six different blades in shapes from

a "V" to a flat "U." Keep a stamp pad and paper handy so you can test the stamp as you work.

Also try experimenting with other potential carving tools from around the house, such as a julienne cutter, a zester, graters, tweezers, and cookie cutters.

Remember that the top and bottom of the eraser can be used, as well as the sides if you're using a block. If you want a pattern block, you can also improvise from a basic shape: checks, stripes, branches, or the like.

Bicycle inner-tube rubber and foam rubber are other possibilities; simply cut the material with scissors, and glue it onto a stamp block or use a piece of wood as a handle.

You can also use linoleum. It's a fairly difficult material to work with and is best suited for somewhat rougher patterns, unless you're especially good at cutting linoleum.

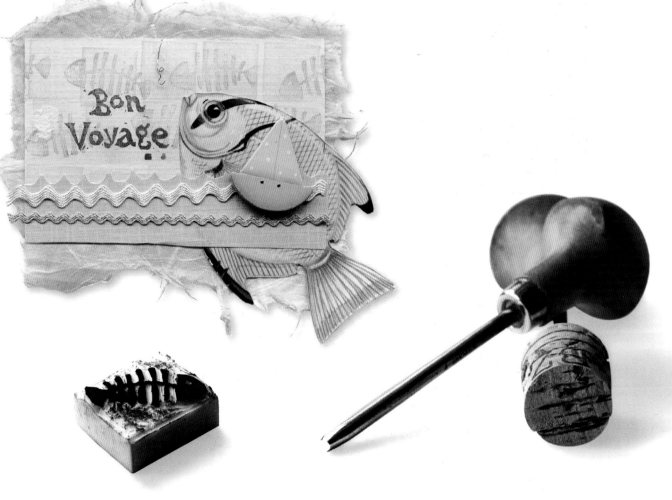

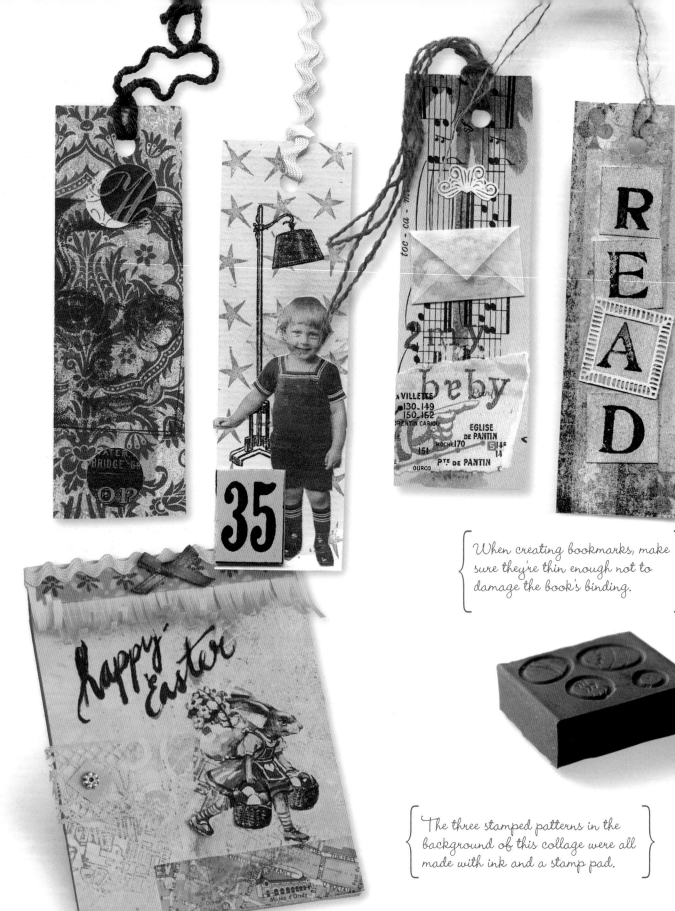

When creating bookmarks, make sure they're thin enough not to damage the book's binding.

The three stamped patterns in the background of this collage were all made with ink and a stamp pad.

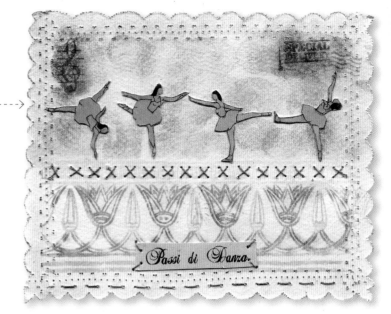

The broad lotus border was created with an unmounted stamp purchased online. The soft and slightly delicate pastel colors were dabbed on with a cotton ball, and then sprayed with fixative. The ballet dancers were cut from a postcard. The frame was stitched over with an unthreaded sewing machine.

Stamping Inks

The stamp pad is your first requirement. It's easy to use and available in many colors, tones, and sizes. Remember, if the stamp is larger than the pad, dab the ink onto the stamp (instead of the reverse).

For something a little different, try pastels instead of ink for a flat, cloth-like sheen. Using a transparent stamp pad or a clear embossing ink pad, stamp a clear image onto your paper and dab on pastels with a cotton pad. You can supplement this by adding more layers with a cotton swab, creating a fine color play on individual motifs. Pastels are available in many forms, including boxes with eight coordinated colors in each one. Applying a fixative afterwards is a good idea; it keeps the pastel where you put it.

There are also stamp-inking pens, which are used to draw color directly onto the stamp and give your motifs some color play. You can also draw on the stamped image with India ink, watercolors, colored pencils, or other kinds of paint.

Another option is to dip your stamp in liquid paint or ink. The best-suited materials for this purpose, we're convinced, are thin liquids, such as airbrush inks. These inks are available in an unbelievable number of colors and shades, and are easy to mix, so you can get exactly the color you're looking for.

To avoid making a mess of your colors, use a pipette to suck up a little paint and then drip it onto a watercolor palette. Pipettes are available in both glass and plastic, and can be found in most drugstores and arts and craft retailers.

The reason that thin liquid inks are better to work with than other kinds of paint or ink is that they dry more slowly and clump less. Rubber stamps in particular have many delicate lines and fine details. If, say, India ink is allowed to stay on the stamp for just an instant too long, the details get smudged together. The image will be imprecise, and since dried India ink doesn't always dissolve in water, it can be a formidable opponent to a fine rubber stamp.

For stamps with a shorter life span—such as those made from crosscut vegetables or rough-textured wine corks—don't worry about clots or fine lines. These characteristics may add to the expression in a positive way.

Clean the working surface of your stamp after each use so that old bits of ink and paint don't contaminate your colors; black bits on a light stamp pad will muddy them. Dry the working surface of the stamp with a cloth or a cleaning pad, or use a spray cleaner—all available from your craft supplier. And for the best stamping results, choose smooth paper over rough paper, and matte over glossy paper.

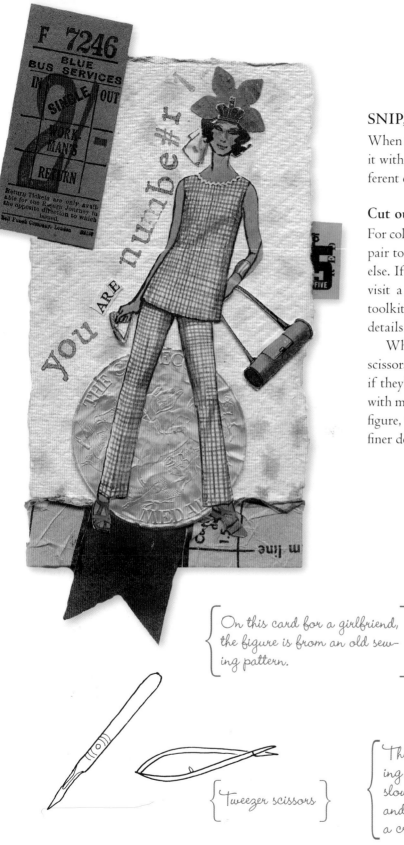

SNIP, CUT, TEAR

When working with paper, you can snip it with scissors, cut it with a craft knife, or tear it. Each technique yields a different effect, and each has advantages and disadvantages.

Cut out, Cut off, Cut in

For collage, you'll need two pairs of scissors: a small pointed pair to snip out fine details and a larger pair for everything else. If you're particularly attached to a very minute detail, visit a drugstore and purchase tweezer scissors for your toolkit. Carving with a craft knife works well for very fine details within the motif.

When it comes to shaped edges on lightweight paper, scissors work best, while straight edges will be more precise if they're sliced with a knife or paper trimmer. For figures with many detailed lines, cut roughly all the way around the figure, then cut the easy straight lines, and follow with the finer details.

{ On this card for a girlfriend, the figure is from an old sewing pattern. }

{ Tweezer scissors }

{ The starting point was the photo of the dancing man. The rest of the elements accumulated slowly. The bingo cards were purchased online, and the striped background is printed paper from a craft store. }

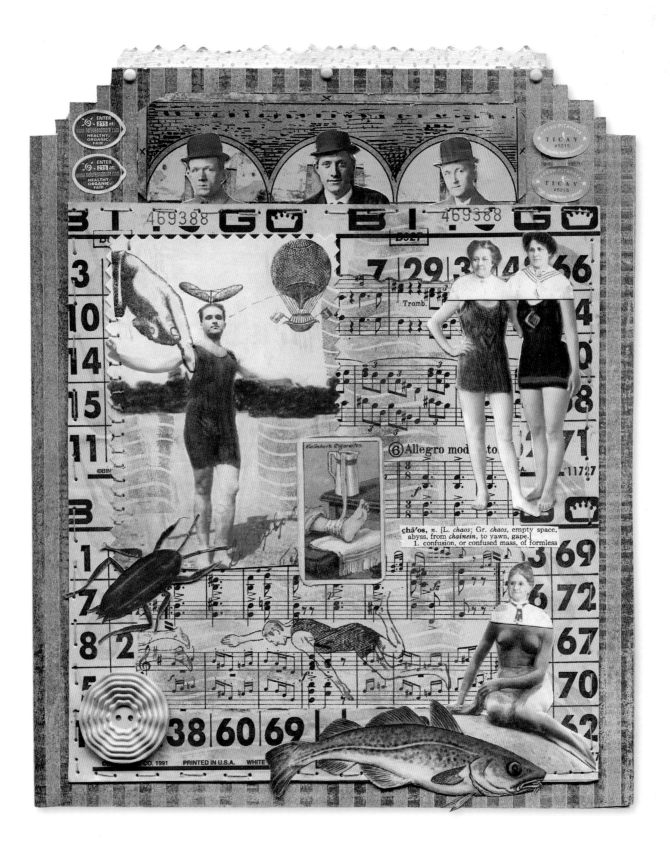

Cut It Out!

A box cutter is a good all-around knife for collage work. Available in a variety of sizes and in plastic or metal, it consists of a handle and a long replaceable blade, the point of which can be broken off when one blade is worn. The best box cutters have a simple locking mechanism, so that the blade doesn't slip while you're cutting.

A utility knife is good for making rougher cuts and is completely indispensable if you have to cut very thick or hard cardboard.

When you cut with a craft knife, you get a very straight and precise edge—especially when you use a cutting mat and a metal straightedge—so it's perfect for fine lines. It's as sharp as sharp can get and will slice through most materials as if they were room-temperature butter. A craft knife comes with a flat or rounded handle of metal or plastic, and with a wide, curved blade or a narrow, pointed blade. The kind with a flat, metal handle and an angled blade is our favorite because of its flexibility and ability to handle most jobs.

It you're cutting straight lines, you can either use a metal straightedge or cut freehand. If you must, you can make do with a plastic ruler, but there's always a risk of cutting into it, making both your cut and your ruler crooked. If you're using a strip of paper as a border, you can measure and mark on the back of the paper, using a square or cutting mat to help you cut a straight line. An "almost" straight line—cut without a straightedge—has its own charm, though.

Cutting mats come in different sizes, often with a grid to help square up your cuts. Most types won't dull the knife blade, are self-healing (they close up knife cuts), and are extremely durable.

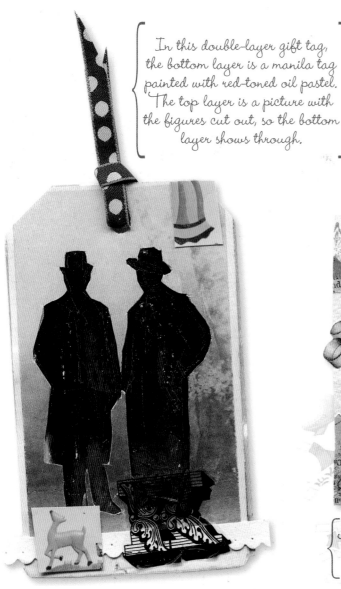

{ In this double-layer gift tag, the bottom layer is a manila tag painted with red-toned oil pastel. The top layer is a picture with the figures cut out, so the bottom layer shows through. }

{ The new address is on the back of the card. The gold crown was purchased from an online craft supplier. }

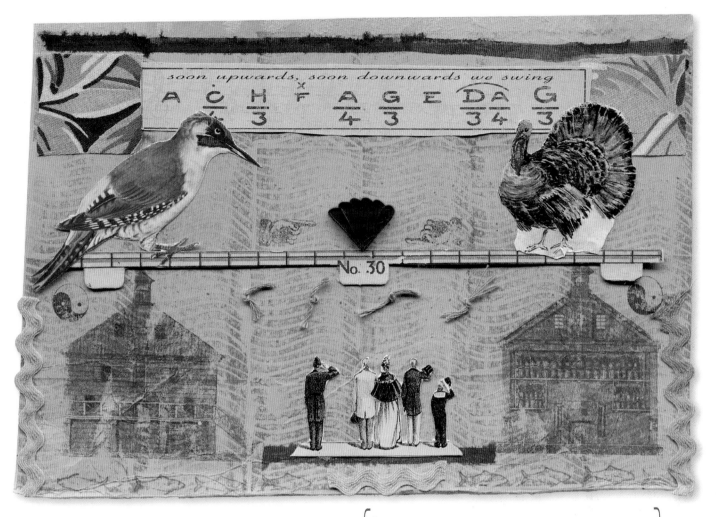

To cut corrugated or very heavy cardboard (½ inch [1.3 cm] and thicker), we recommend that you use a metal straightedge. Lay the cardboard on the cutting mat with the metal straightedge in place on top, press down hard on the cardboard, hold the craft knife or box cutter so the blade is vertical, and cut. You may have to go over the cut several times. Remember to change—or break off—the blade as soon as you suspect that it's getting dull.

Don't let your cutting tools lay loose around your workspace. If possible, retract the blades, and store your knives in a metal case, or stick the sharp ends into corks. And it goes without saying: keep them well out of reach of children.

Right, left to right: Retractable craft knife with snap-off blades, retractable box cutter with snap-off blades, basic craft knife with replaceable blades

The small figures are from a new reprint of an old cutout sheet, and the birds are stickers. A leftover piece of cloth—perfectly color coordinated—found a friend in the dark red, fan-shaped button from the sewing box.

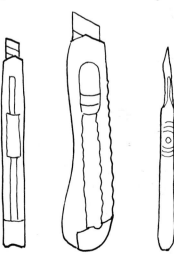

Tearing through Your Work

For something more organic than a clean, sharp edge, try tearing your paper. For smaller objects, such as a strip of paper with text or a pattern, crease where you want the edge, score it with your thumbnail or a bone folder, and rip carefully with tiny tugs.

For longer tears, place a straightedge along the tear line, press down hard on the straightedge, and rip carefully.

To divide a large sheet of soft, heavy paper—such as rice, cotton, watercolor, or handmade paper—into smaller pieces with the same fuzzy edges as the large sheet, you'll need a thin brush and a little water. Lay a straightedge along the tear line, score the line with a bone folder, and fold the paper up along the score. With the straightedge still in place, brush water along the straightedge several times on both sides of the paper. Give the water time to soak into the paper—the heavier the paper, the more water and the longer time it will need. When the tear line is thoroughly soaked through, carefully pull the paper apart to get that fine, fuzzy edge. In addition, so-called ripping straightedges (or deckle tools) are available with various profiles.

FOLD IN, FOLD OUT

Short creases in thin paper can often be folded directly by hand. For heavier paper and light cardboard, it's helpful to mark the creases first so that they'll be straight as an arrow. With a marked crease line, you avoid a "broken crease." Measure and mark where each crease is to lie, place the straightedge along the fold line, and then score the line with a bone folder or any other instrument with a rounded point. To fold a fan, turn the paper over for every other line. To fold a single sheet into a folded card, score the inside of the fold.

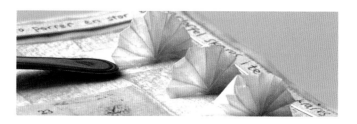

Created for our friend Carl's 90th birthday, this collage incorporates details that evoke particular memories.

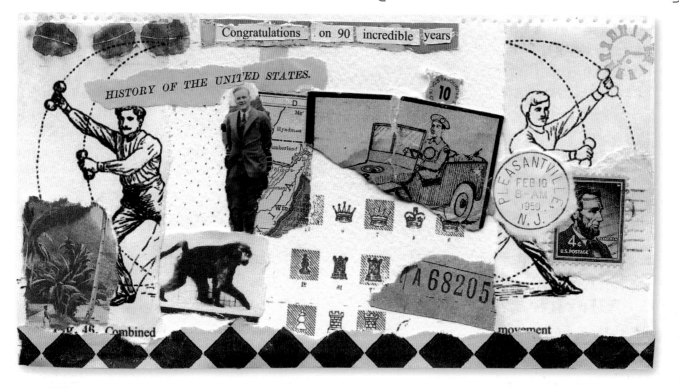

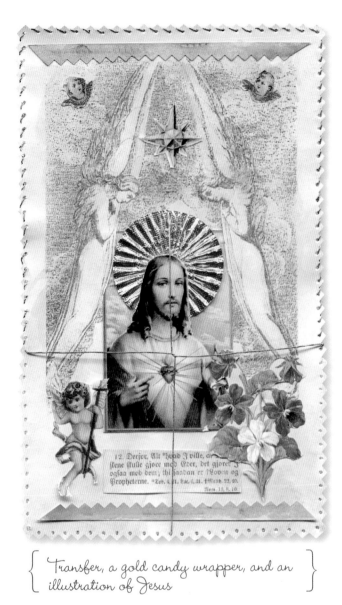

{ Transfer, a gold candy wrapper, and an illustration of Jesus }

THERE'S A HOLE IN IT!

You can create all sorts of exciting effects by punching holes in paper with a variety of tools—an embroidery needle, a sewing needle, a fine knitting needle, an awl, a tracing wheel, or any sharp or pointed tool—or by using a sewing machine without the thread.

To make holes in paper, first place the paper on a soft layer such as a blanket or piece of felt. To pierce a smaller area with, say, a darning needle, sink the blunt end of the needle into a cork stopper—so you'll have something to hold on to—and lay your work on a big, flat eraser. If you're tracing a pattern or a motif with holes, draw the shapes lightly with a soft pencil directly on the background and erase the marks afterwards. For squares, use a piece of grid paper as a tracing pattern. Be aware that the front of the punched paper will appear quite different from the back.

Larger holes can be created easily with a standard hole punch or a leather punch. Plenty of small punches in various shapes and edges are available for paper of the usual thickness, as well as hand punches with different shapes and edgings, with some brands able to handle cardstock.

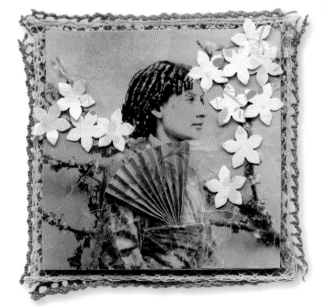

{ The flower shapes and the fan are both made of wrapping paper. }

A PATTERN IS EMERGING...

A pattern is the predictable repetition of a shape or an element over an area. There are many ways to manufacture your own patterned paper.

A simple method is to cut a pattern element onto an eraser and systematically stamp a whole surface, field, or edge. You can also choose to use a number of different pattern blocks of the same size, which will give a more varied pattern. In the same way, you can use practically any kind of stamp (see pages 92 and 94).

Another simple technique is to draw the background. Don't worry: you don't have to be an artist to achieve a decorative result. The starting point can be a piece of colored paper or watercolor paper, optionally washed with watercolor, tea, coffee, or turmeric water. To use turmeric for a beautiful, golden tint, simply dissolve the turmeric in boiling water, using ½ to 1 teaspoon for each 3 to 4 tablespoons of boiling water.

These two place mats shown above and on the opposite page were made small (6¾ x 4 inches [17 x 10 cm]), enlarged on a copier to 200 percent, and laminated for durability.

To make the pattern precise and completely regular, draw in a grid of some sort with a fine, light pencil line; if you prefer a more natural appearance, rough it in freehand. You can also score lines with a straight pin, so later on the framework will be completely invisible. Now, draw the same figure in each field. The figure can consist of nothing more than three dots and two lines, three crosses over each other, a flower, a coffee cup drawn from a photo and transferred (as described on page 111), or a pair of curves drawn freehand. It's surprising how fine a result you can attain with dots, lines, crosses, zigzags, or squares alone, or in combinations. And if you expand your paint selections to include watercolor, colored pencil, and India ink, you'll get even more variations.

{ "Eat" and "drink" in different languages were stamped on the background with alphabet stamps. The blue and white china dishes were cut out of an advertisement. The blue edging was made by using a cotton swab to dab on glossy acrylic paint. }

{ The grid was measured out with a clear plastic drafting triangle and then scored with a needle. }

GLUE, INDISPENSABLE GLUE

When building collages, it's important to become familiar with a variety of adhesives because you'll need different kinds for different materials. Acid-free (or water-based) adhesives are preferable for collages that you want to last a long time, but if the collage is a congratulations card or another short-term project, durability shouldn't be too important. (Read all about acid-free paper on page 37.) Avoid products that don't list their ingredients.

Fasten elements down only when you're sure of their placement and when you know that there will be no other elements behind or underneath them. Removing an element once it's been well attached can be difficult, and maybe even impossible—especially if you're working with thin paper.

To glue two elements of equal size together, make sure there are no air bubbles between them. Using a glue stick, spread the glue on the heaviest piece—if there's a difference in weight—and lay the lighter, second piece on top, smoothing it on bit by bit.

As a rule, when you adhere smaller pieces of paper to larger ones, putting the glue on the smaller piece is best. Begin by laying the element on a piece of scrap paper. Then spread the glue out to the edges of the element, and put the element in place on the larger one. If it's especially tiny, tweezers can be helpful for this step.

Try to keep at least two or three different adhesives on hand at all times.

A glue stick is a must. Quick, practical, and easy to work with, glue sticks can be found in many widths and in acid-free forms. You can use them on all kinds of paper and cardstock, and even between layers of cloth and paper.

PVA glue is a clear-drying liquid adhesive that can be used on all forms of paper. It often comes in a plastic container with a point, allowing for easy application.

A glue gun is an electric "pistol" of sorts that warms special sticks of glue until they become liquid. This glue is extremely effective, very quick drying, and is phenomenal for wood, metal, and plastic pieces.

White craft glue is used for gluing various materials such as wood, cardstock, glass, ceramic, fabric, and so forth. This glue comes in a plastic bottle with a point—for slow drying—and in small tubes with a very fine point—for quick drying—making it well suited for gluing minute elements in place. Excess glue can be rolled off if done with care.

Three-dimensional glue dots are small adhesive pads that raise particular items off the surface of a collage. They come in various sizes and give a little depth to a collage.

Double-sided tape is tape with a paper cover on one sticky side. Cut a little piece off, put the uncovered sticky side on the object—possibly in each corner, if necessary—then remove the paper backing and affix the object in place. This special tape is great for photos and such, and with a little care, can be removed.

Adhesive putty—plastic glue that can be shaped like modeling clay—is useful for attaching things such as pens and dollhouse paraphernalia.

In addition, there are **glue pens** and **white glue paste** that's applied with a brush.

Spray adhesive is not recommended for collages. It's expensive and difficult to use on a limited area, and the fumes are hazardous.

{ Gift tags }

REEN & COMPANY,

Central and South America pictures including Brazil, Argentina, Peru, Ecuador, Colombia, Chile, Costa Rica, Venezuela, and m

Arne Rudalsauen, Norge.

48

mio

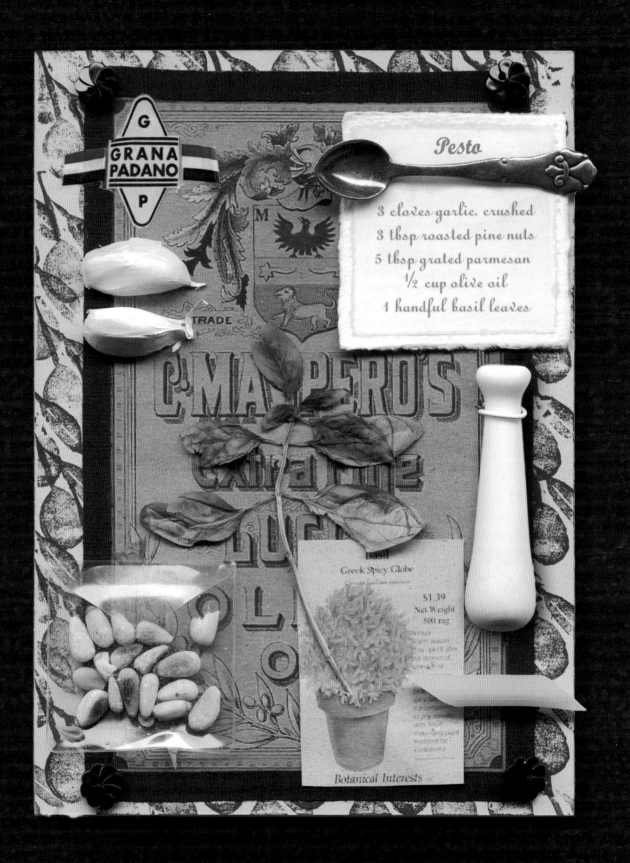

GRANA PADANO

Pesto

3 cloves garlic, crushed
3 tbsp roasted pine nuts
5 tbsp grated parmesan
½ cup olive oil
1 handful basil leaves

C. MALPERO'S

TRADE

Greek Spicy Globe

$1.39
Net Weight
500 mg

Botanical Interests

TRANSFERRING IMAGES

Transferring line drawings and figures is a decorative technique that offers many exciting choices.

Photocopied photographs can be transferred, as long as you keep in mind that the results may be somewhat muted. For a successful outcome, the image must be produced by a photocopier or laser printer, both of which use toner. Unfortunately, because an inkjet printer uses liquid ink, it won't produce a useful transfer.

Remember, most photocopiers can reduce or enlarge an image, so if the image isn't exactly the size you need, simply adjust the size.

Transfers are created using a blender pen or with acetone. The blender pen is a large, colorless, felt-tip pen. It's marked "nontoxic," but it smells a little noxious. Put the lid back on every time you use it so it will last longer. (When the pen is almost used up, extend its life by placing it in acetone for a while.)

You can also accomplish the same transfer technique using a little acetone in a jar with a screw-top lid and brush. No matter which method you choose, work in a well-ventilated area, and make sure to air out the room during and after the process.

The artichoke and globe transfers are from a collection of copyright-free vintage illustrations.

You'll also need a bone folder for this process. The background should be smooth, with a matte finish rather than a glossy surface. Fine watercolor paper will work, but bumpy paper will give an unclear image.

When the image is transferred, it will be a mirror image. If there's text in it, you must first reverse it, unless your photocopier's reverse function can take care of this beforehand. One way is to photocopy the image onto an overhead transparency and then place the transparency upside down on the copier's screen before copying it.

Reversing the image in a photo-editing program is also possible, but this means the image must be scanned, saved, and then reversed. There are countless images available, so you should never worry about running out of material, but be sure to save your reversed images for later use.

If you've collected a number of small, loose images, it's a good idea to paste them onto an archival sheet, so you won't make more copies than absolutely necessary.

Our experience has shown that transferring works best when you copy or print on ordinary photocopy paper. Begin by placing the image print side down. Start with a relatively small image, so that you can become confident with the technique before leaping into a large-scale transfer. To make the illustration sharp and clear, make sure your original print doesn't move during the process. Acetone evaporates very quickly, so you'll have to work fast. Draw or brush over the illustration so that it's damp and stands out; then quickly rub over it with a bone folder. With larger illustrations, dampen and rub only one small area at a time. When the dampened area has been rubbed thoroughly, the image is transferred.

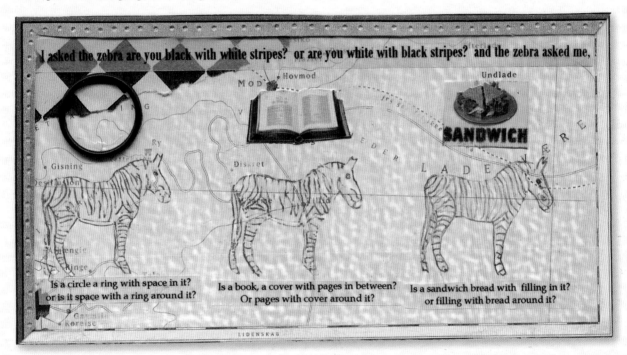

{ The text on the collage is an excerpt from Shel Silverstein's long poem "Zebra Question." }

An easier method of transferring is with a pencil tracing. Pencil transfer works best with simple line drawings. Trace the illustrations with a sharp, soft pencil (HB or B) onto tracing paper, cooking parchment, or other semitransparent paper. Place the drawing face down where you want it, and then trace your lines so that the underlying pencil line is transferred to the paper underneath. Finally, rub the drawing with a bone folder (see page 63 for an example). The drawing will be a mirror image of the original.

If you want the image to appear normal—not as a mirror image—trace your own lines on the reverse side of the tracing paper before you transfer the image. Place the tracing face down where you want it, and retrace the lines onto the underlying paper.

PHOTOGRAPHS

Photographs are springs of inspiration that never dry up. Whether you want to collage a family event, make a commemorative collage, or make up a story by hunting down obscure photos and postcards of unknown people, photographs are a priceless resource.

A world of possibility exists online. You can buy old photos—in digital form, as paper copies, or as originals—in a variety of places online, and there are many sites with photographs for free use. These pictures are normally of good quality when printed out, but remember to save the pictures in the largest possible format, adjusting the size later, if necessary, with your photo-editing program. If the photos aren't for free use, they're often in a format that can't be printed out in a usable quality.

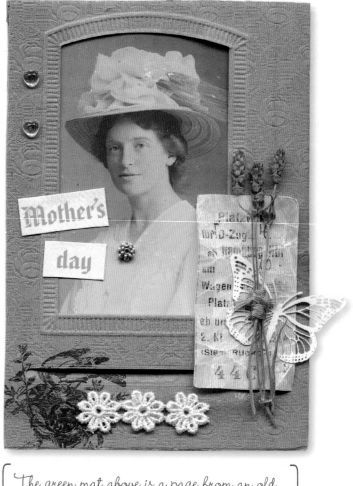

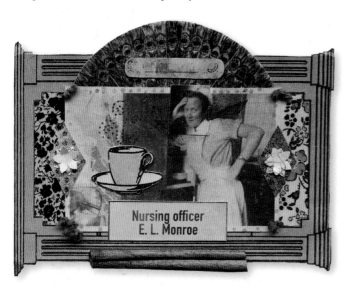

Because photographs of relatives are considered treasures in most families, you'll most likely have to scan them and print them out when you want to use them in a collage. The advantage of using copies is that they're much easier to adapt and change, even for newer photos that may not be quite as evocative as older ones.

If you want to hand-tint a photograph, the surface must be matte rather than glossy or the paint won't hold. In general, lighter photos are best for tinting. Recent color photos,

The green mat above is a page from an old photo album found at a flea market. The lace-cut butterfly is from an online store.

once changed to a black-and-white format, are ideal to paint as long as they aren't too dark. Make sure to copy them onto heavier paper, as well. If you're comfortable working with it, watercolor is a fine medium for tinting, but if you lack confidence with wet paint, colored pencils offer an easy alternative. Be sure they're very sharp, and work with a magnifying glass so that the finer details are precise. Give the photo life and texture by using many shades of color.

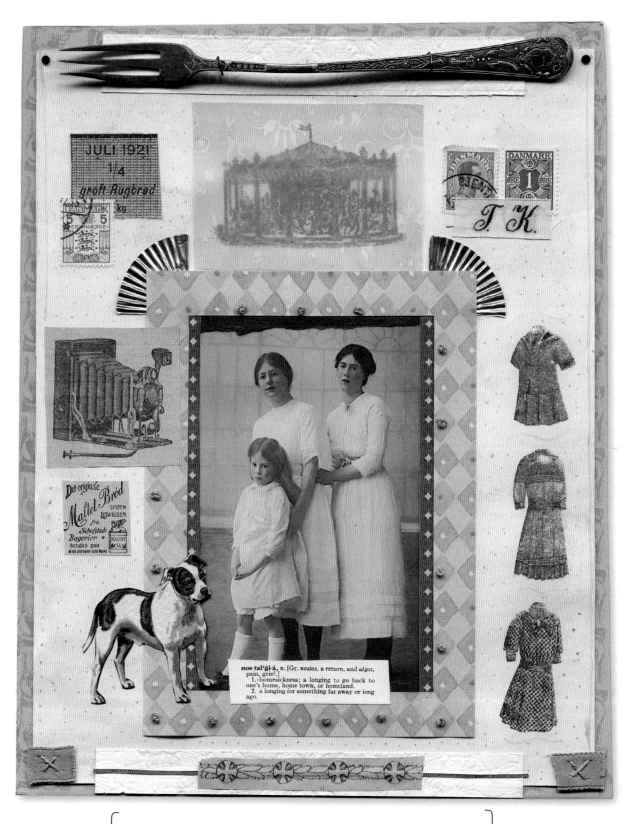

nos·tal'gi·a, n. [Gr. nostos, a return, and algos, pain, grief.]
1. homesickness; a longing to go back to one's home, home town, or homeland.
2. a longing for something far away or long ago.

{ The picture of three sisters was printed on paper with a matte surface and then tinted with colored pencils in pastel shades. }

SAYING SOMETHING WITH LETTERS

There are many sources and techniques to choose from if you want to include letters and text in your collage.

Alphabet stamps are available in many variations. The individual letters take up a fair amount of room, so they're best for short and simple words, names, or headings. The same is usually true for letters clipped from newspapers and magazines—which are rarely printed on acid-free paper—tiles from word games, alphabet stickers, and the like. Scrapbooking supply stores and websites offer even more possibilities.

{ A recipe for a favorite cookie, to be hung up in the kitchen } ----->

{ For this children's collage, the text was copied from a dictionary and painted with a thin coat of watercolor. }

When using handwriting, it's a good idea to write lightly in pencil first onto paper or another material, which can be glued onto the collage itself later. Another very entertaining idea is to cut text out of books. You can find wonderful words and phrases in novels and collections of poetry—words that can take on new life when placed in relation to your collage elements. Encyclopedias and dictionaries are loaded with possibilities, and then, of course, there are old letters, which can be both decorative and meaningful.

Last, you have text options with various computer fonts. If you buy a word processing program, it will usually come with a long list of fonts. In addition, you can download fonts online by simply searching for "free fonts" with your search engine. A great majority of the fonts are free and are compatible with any type of computer. Normally, directions are provided to help you download the fonts to your computer and allow you to access them just like those you already have.

32 Chocolate cookies

70 g roughly chopped plain chocolate, 70%
35 g raw sugar
200 g unsalted butter, chilled, diced
140 g muscovado sugar
275 g plain flour (or half wheat, half spelt)
½ tsp vanilla extract
½ tsp orange extract and grated zest of 1 organic orange

Preheat the oven to 180 ºC / 350 ºF.
Place the chocolate and raw sugar in a food
processor and beat until it's like sand.
Add butter, muscovado sugar, flour, extracts and grated
zest and beat well until the dough is mixed.
Place baking parchment on two cookie sheets.
Form 32 walnut size balls and put 16 balls
on each sheet spaced well apart.
Bake for 10-15 minutes until the cookies are a little darker
at the edges. Leave to cool on the baking sheets for another
10-15 minutes. Store in an airtight container for up to one week
– but are normally eaten by then.

For longer sections of text such as a recipe, a letter, or a dream, type the text in the font you would normally use. When you've finished typing, change the columns, font, size, and text color in any way you wish. Once you've formatted your writing and printed it out on the appropriate paper, you're free to work on it even further. You could tone the paper with a colored wash; draw, stamp, or adhere borders to it; tear it, then brush the edges with a somewhat stronger color; burn the edges; cut the edges with pinking shears; prick an edging with an embroidery needle; and so forth and so on. Give the text some dimension by gluing it to cardstock and cutting it out. Emphasize it even more with three-dimensional adhesive dots, which will lift the text off the background.

I enjoy constructing
unfinished paintings,
It's interesting meditative,
to make a huge mess
very relaxing

EMBROIDER A LITTLE, SEW A LITTLE

A sewing machine can liven up your collage by allowing you to sew on elements, or by simply letting you use the stitches or perforations as decoration. When the background is very heavy, it may be necessary to sew very slowly, turning the wheel by hand rather than using the foot pedal. If the machine can create embroidery stitches, they'll provide an endless supply of borders. Try sewing close stitches without thread to make a decorative edge.

If you're a hand sewer, it's a good idea to punch the holes you'll need first, so that you don't risk bending or breaking the background. This will also assure better precision, since every other stitch will come up from the back. Pierce the background from the front with a thicker needle than the thread you plan to sew with; this will allow the thread to slide easily though the hole. You may want to use a big eraser underneath as a pad. To sew cross-stitch, use a piece of grid paper as a guide; other forms of embroidery can

simply be drawn on the paper. Sew these stitches with a somewhat finer needle.

Any kind of embroidery stitch can be used, but the stitches can't be too close together or they'll form a perforated line, and the paper will fall apart. We recommend cross-stitch, French knots, single and double tacking stitches, lazy daisies, binding stitches, and outline stitches.

NEW BECOMES OLD

Those who lack the patience to wait for their materials to age naturally will have to help the process along. There are various ways to age a new print or other brand new elements with a little patina. Paper and cardstock can be dipped in black tea, strong coffee, an India ink/water solution, or other colored liquid, and then laid out to dry and ironed. If there's handwriting on the paper, test it first to make sure that the ink used on it is permanent and won't run.

Paper can also be crumpled up and flattened out again. It can be distressed by rubbing it on the ground, walking on it, or rubbing it with charcoal, while shellac will give it a glossy, yellowed surface. The edges can be burnt (carefully!), or they can be scraped with a knife or your fingernails. Try smoothing your paper—including old photos or copies of them—over hard surfaces or with fine sandpaper.

BUILD OUT AND BUILD UP

When you evolve beyond the world of two-dimensional collage, possibilities open up for the use of new materials in your work.

Paper can be folded like napkins, into fans, or into origami forms that resemble wrinkled or pleated fabric. You can even knit and crochet flowers or miniature clothing from embroidery floss. Felt flowers, handmade buttons, tassels, and fringes are other good effects.

Make sure that the background is heavy enough to support these elements—which can be bonded to cardstock or chipboard—and be careful to adhere the objects well enough so they won't fall off. Some things are best fastened with strong glue, but using wire, string, yarn, screws—and sewing—are all suitable forms of attachment, and sometimes lend a touch of humor. As a rule, you need to poke holes in the background so that the wire, string, or screws can be pulled through, but don't make the holes larger than absolutely necessary.

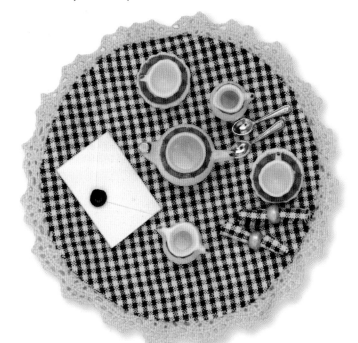

The list of suitable elements goes on and on, but those listed below are some we've come across up to now. Here are some small objects suitable for collages:

Beads (pages 11, 19, 32, 33, 45, 56, 85, and 114)
Bottle caps (pages 19 and 46)
Buttons (pages 5, 41, 62, 74, and 101)
Candies (page 19)
Clock parts (page 70)

Clothing hooks and snaps (pages 18, 41, 64, 71, and 81)
Coins (pages 5, 31, 32, and 77)
Cookie cutters or small pastry molds (page 95)
Cork stoppers (page 13)
Dollhouse furniture, dishes, etc. (pages 24, 115, and 117)
Eyeglasses
Feathers (page 12)
Flower buds and leaves (pages 11, 14, 31, 37, 48, 59, 75, and 78)
Game pieces—board game and puzzle pieces (pages 31, 36, 56, and 115)
Hair clips and clothespins (page 23)
Jewelry parts—findings, pendants, charms. (Snip off the jump rings!) (pages 32, 67, 89, 96, and 120)
Keys (page 50)
Knitted and crocheted pieces (pages 19 and 58)
Metal fittings (pages 18 and 51)
Military and other medals (pages 22 and 58)
Nuts and bolts (pages 21 and 70)
Pen nibs (pages 18, 33, 58, 78, and 119)
Perfume samples

Plastic animals (pages 66 and 94)
Seashells, stones, and dried starfish
Silk flowers and bows
Small sticks—knitting needles, etc. (pages 5, 20, 40, and 72)
Small toys (pages 66 and 94)
Spoons, forks, and other flatware (pages 42, 91, 109, 113, and 117)
Tassels and fringes (pages 44, 84, and 116)
Twigs, matches, and lollipop sticks (pages 5 and 31)
Whole spices such as star anise, cardamom, allspice, and coffee beans (pages 29, 59, 63, 77, 109, and 115)

34 ways to jumpstart a collage

Dip a piece of paper in tea.

Cut out a simple stamp and make a repeating pattern.

Glue a patterned background onto cardstock.

Poke out a pattern with a needle.

Sew a few French knots onto a sheet of paper.

Cut an edge with pinking shears.

Crumple paper and flatten it out again.

Fold paper into a fan and unfold it.

Sew a button onto paper.

Draw a pattern with pen and ink or liquid colors.

Transfer some text using the technique on page 110, and begin a collage using the words as a starting point.

Cut a shape out of a sheet of paper.

Sew or glue a piece of fabric onto paper.

Paint half a sheet of paper with a color you like.

Rip a page out of a book, and brush water-based transparent paint over it so the text still shows through.

Sew beads around the edge to create a decorative border.

Paste postage stamps symmetrically on a piece of paper.

Find three elements with coordinating colors.

Glue a cutout to a random point on a map or decorative page.

Place a frame (a photo mat or edging) on a prepared background.

Punch holes from different papers, and spread the dots on a sheet of paper.

Cut out a paper doll or a figure from a magazine to start a little story.

Paste a piece of crumpled tissue paper onto a piece of chipboard.

Paint a sheet of paper by mixing the paint directly on it. Dip the brush in water, dip it in the color, dip it in a new color, and paint away.

Make a frame on a piece of a paper using coins, matches, or grains of rice. Stamp or draw lines if you like.

Paste a sheet of cardstock or chipboard on paper, letting it extend beyond the edge of the paper.

Paste a playing card back side up on a sheet of paper.

Dip a piece of gauze in liquid color, let it dry, and paste it to paper.

Scratch a hole in paper with a little knife and machine stitch over it.

Paint a crumpled supermarket receipt with transparent watercolor and paste it onto paper.

Roll some color onto a sheet of paper with a foam brayer (available in art and craft stores).

Place a coin under a sheet of thin paper, and rub it with a soft pencil or colored pencil.

Cut an old postcard into pieces and reassemble it in a different order.

Dip the wheels of a toy truck in ink or roll them on a stamp pad, then drive the truck across a sheet of paper.

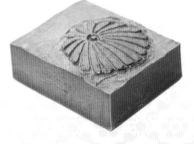

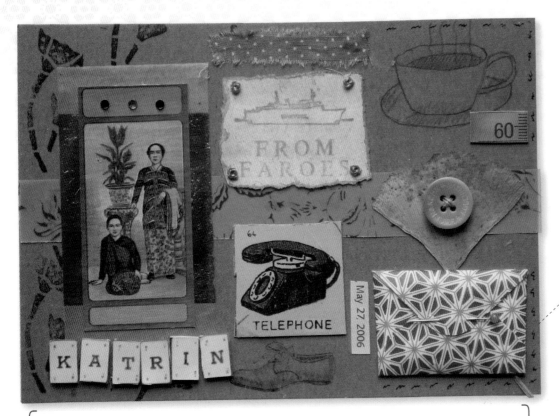

{ For my friend Katrin, who comes from the Faroe Islands. The card reflects the things we have in common. In the little hand-folded envelope is a letter with good wishes. }

{ For my friend Poul Henrik's 50th birthday. As you can see, he has chickens and fish, builds ships, and plays golf. He is an avid reader, has a sharp pen, and likes kiwi fruit, New York City, and music. }

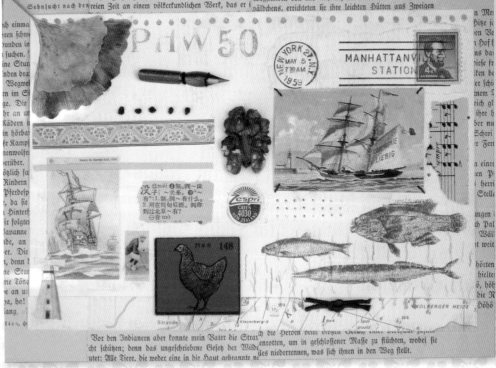

19 ways to create pattern and structure

Vegetable and fruit stamps

Rubber stamps

Pen and India ink

Brushes, watercolors, or gouache

Oil pastels

Pastels

Rubbing (For example, lay a coin under paper and color over it with a crayon.)

Fold or crumple paper. (Try tracing the folds with a colored pencil or India ink.)

Use the stamp pad as a stamp.

Make cuts in paper and fold up the edges.

Score the paper with a sharp needle.

Machine stitch the paper without thread.

Embroider the paper with a needle and thread.

Make a transfer.

Use a cotton swab dipped in paint.

Tear strips of paper and braid them.

Use a compass to make circle patterns.

Shellac the paper with a brush, foam applicator, or cotton ball.

Write all over the sheet by hand, covering the paper densely.

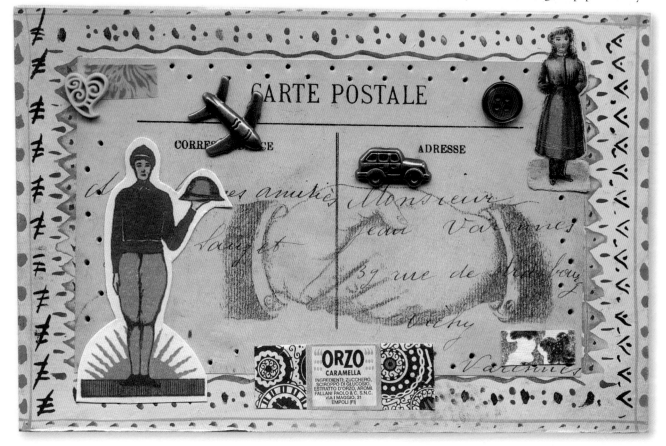

48 themes in no particular order

Favorite recipes (You can write on the back where you learned about the dish.)

Memorable vacation

Grandmother collage, featuring her interests

Party collage for weddings, birthdays, holidays, and other special occasions

A walk in the woods

A walk on the beach

Family tree collage

A birth collage with information about the time, place, weight, etc.

Remodeling the house—before and after

Any period in one's life—youth or school collage

A collage for losing weight

A garden collage, perhaps with pressed flowers and seed packets

A wardrobe collage or a dream wardrobe collage

A furnish-your-home collage

A friend collage

A career collage: what I've attained or what I want to attain

A dream collage: "One night I dreamed..."

Your dream trip

Future goals or accomplishments

A personalized child's picture book with elements and pictures from everyday

Educational children's book with buttons, zippers, and shoelaces

Memory collages

Knitting, sewing, or other hobby-inspired collage

Golf or other activity collage

Scouting collage with badges and knots

Invitation collage

Wish list collage for birthday or holidays

The four seasons

The bottom of the sea

Dolls

My idol collage

Collage of little things I like

Culture collage of a particular civilization, part of the world, or period in time

Dictionary collage

The alphabet

"Congratulations!" collage

Picture book for very small children, with animals

Valentine's card

Mother or Father's Day

Easter collage

Christmas card

New Year's card

Neighbor collage

Bon voyage collage

Host or hostess present

Color collage

Date collage

Thank you collage

SHOW IT OFF, BUT PRESERVE IT WELL

Once you've produced a certain number of collages that you haven't given away or used for specific purposes, the question of how to preserve them will come up. Seeing a half-forgotten collage again can be very heartwarming, so you might think about storing your past creations the plastic sleeves of a ring binder, or laying them in a box where they can be revisited regularly.

But there are other options that will enhance your works' visibility. If you have room on your walls, framing your pieces is an obvious choice. For flat collages, try to find frames that go with them, either old or new, depending on what you think works best. If you have a small collage and a large frame, the problem is easily solved with a mat, which, by the way, may offer more options for further work on the piece.

If the collage includes three-dimensional elements, framing is an entirely different matter. The offering of frames with depth is limited in both format and appearance. If the frame itself is deep, try extending the back with narrow molding to make more room under the glass, kind of like a shadow box. You can also order deep frames from a framing store or make your own using prefabricated moldings. Another option is to mount your work on fiberboard and hang it with wire.

A well-chosen file box—with dividers for protection so the collages can stand like index cards—makes for a good storage option. A narrow shelf with a lip is ideal for temporary exhibitions, as are easels, which are available in tabletop versions. Additionally, you can use insect or butterfly display cases.

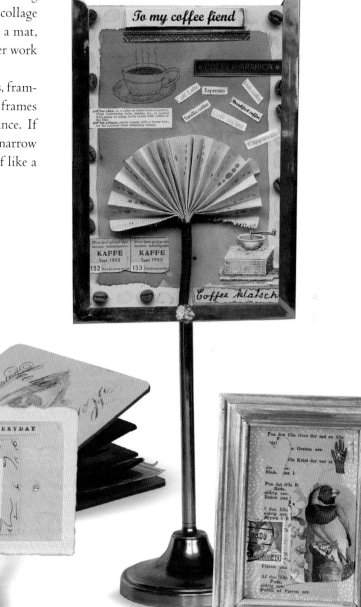

{ Hostess gifts }

About the Authors

ELSEBETH GYNTHER is an editor, a novelist, and the author of several books on how to make clothing, including *Easy Style: Sewing the New Classics*. She has also worked as a fabric designer and as a creator of children's wear collections. Elsebeth's love for collage—which felt to her like a coming home—began five years ago. She held her first exhibition on the Faroe Islands.

CHRISTINE CLEMMENSEN graduated from the Graphic Arts Institute of Denmark in 1999 and has worked with graphic design ever since. Christine maintains a blog at www.christineclemmensen.blogspot.com that's full of illustration, inspiration, photography, and, of course, collage.

PAPERBINDERS

100 Stk.

Nr. 3

COLLAGE DIMENSIONS
(Measurements provided as width x height)

Elsebeth's Collages

p. 2, Lying in State: 4^{15}/$_{16}$ x 6^{7}/$_{8}$ inches (12.5 x 17.5 cm)

p. 10, Invitation: 5^{7}/$_{8}$ x 8^{1}/$_{4}$ inches (15 x 21 cm)

p. 12, top, Aunt Olga: 7^{7}/$_{8}$ x 5^{1}/$_{8}$ inches (20 x 13 cm)

p. 13, Greeting: 5^{11}/$_{16}$ x 7^{7}/$_{8}$ inches (14.5 x 20 cm) (1:1 scale)

pp. 14–15, China Series: each 5^{5}/$_{16}$ x 3^{3}/$_{8}$ inches (13.5 x 8.5 cm)

p. 16–17, Alphabet Collages: each 3^{15}/$_{16}$ x 5^{5}/$_{16}$ inches (10 x 13.5 cm)

p. 18, From the Stash: 7^{1}/$_{4}$ x 7^{1}/$_{4}$ inches (18.5 x 18.5 cm)

p. 20, Fiction: 6^{1}/$_{8}$ x 4^{1}/$_{8}$ inches (15.5 x 10.5 cm)

p. 21, top, Spirit: 8^{5}/$_{8}$ x 4^{5}/$_{16}$ inches (22 x 11 cm)

pp. 22–23, Elements: 15^{3}/$_{4}$ x 19^{11}/$_{16}$ inches (40 x 50 cm)

p. 24, right, Garden Collage: 5^{11}/$_{16}$ x 8^{1}/$_{4}$ inches (14.5 x 21 cm)

p. 26, left, Calling Card: 5^{7}/$_{8}$ x 8^{5}/$_{8}$ inches (15 x 22 cm)

p. 30, detail: see p. 2

p. 31, Animals on the Job: 4^{15}/$_{16}$ x 6^{1}/$_{2}$ inches (12.5 x 16.5 cm)

p. 34, For a Child's Room: 4^{5}/$_{16}$ x 6^{11}/$_{16}$ inches (11 x 17 cm)

p. 35, For a Child's Room, frame: 9^{13}/$_{16}$ x 20^{7}/$_{16}$ inches (25 x 52 cm)

p. 37, bottom, Riding the Elephant: 7^{11}/$_{16}$ x 7^{11}/$_{16}$ inches (19.5 x 19.5 cm)

p. 40, Birthday Card: 5^{7}/$_{8}$ x 8^{5}/$_{8}$ inches (15 x 22 cm)

p. 41, left, Sewing Girl: 7^{1}/$_{4}$ x 4^{1}/$_{8}$ inches (18.5 x 10.5 cm)

p. 41, right, My Aunt's Laundry: 5^{7}/$_{8}$ x 8^{1}/$_{4}$ inches (15 x 21 cm)

p. 42, bottom, Jungle: 5^{7}/$_{8}$ x 7^{7}/$_{8}$ inches (15 x 20 cm)

p. 43, Fiction: 6^{1}/$_{8}$ x 7^{11}/$_{16}$ inches (15.5 x 19.5 cm)(1:1 scale)

p. 47, Kitchen Collage: 8^{1}/$_{4}$ x 10^{5}/$_{8}$ inches (21 x 27 cm)

p. 48, top, Goose in the City: 6^{11}/$_{16}$ x 4^{15}/$_{16}$ inches (17 x 12.5 cm)

p. 50, bottom, Invitation: 8^{1}/$_{16}$ x 8 1/$_{4}$ inches (20.5 x 21 cm)

p. 51, Vitruvian Man: 8^{1}/$_{16}$ x 8^{1}/$_{4}$ inches (20.5 x 21 cm)

p. 52, Lonely Dog: 4^{1}/$_{4}$ x 5^{1}/$_{2}$ inches (11 x 14 cm)

p. 54, Ostrich in the Center: 7^{1}/$_{2}$ x 5^{1}/$_{2}$ inches (19 x 14 cm)

p. 55, Congratulations Card: 5^{11}/$_{16}$ x 8^{1}/$_{4}$ inches (14.5 x 21 cm) (1:1 scale)

p. 56, top, Italy 2006: 4^{5}/$_{16}$ x 6^{1}/$_{2}$ inches (11 x 16.5 cm)

p. 57, top, Help! I need Somebody: 7^{7}/$_{8}$ x 4^{5}/$_{16}$ inches (20 x 11 cm)

p. 57, bottom, Paris Opera: 5^{7}/$_{8}$ x 3^{3}/$_{4}$ inches (15 x 9.5 cm)

p. 58, top, 2-B (class picture): 7^{1}/$_{16}$ x 4^{1}/$_{2}$ inches (18 x 11.5 cm)

p. 58, bottom, Catalog Collage: 7^{1}/$_{16}$ x 7^{1}/$_{16}$ inches (18 x 18 cm)

p. 59, top, Swan: 4^{15}/$_{16}$ x 6^{7}/$_{8}$ inches (12.5 x 17.5 cm)

p. 60, Woman with Flower Children: 5^{3}/$_{8}$ x 7^{7}/$_{16}$ inches (13.5 x 19 cm)

p. 61, Queen Ingrid: 4^{15}/$_{16}$ x 6^{7}/$_{8}$ inches (12.5 x 17.5 cm)(1:1 scale)

p. 62, Phases of the Moon: 5^{7}/$_{8}$ x 5^{7}/$_{8}$ inches (15 x 15 cm)(1:1 scale)

p. 63, top, Coffee Collage: 5^{7}/$_{8}$ x 7^{7}/$_{8}$ inches (15 x 20 cm)

pp. 64–65, top, Diary Collages: each 3^{15}/$_{16}$ x 5^{1}/$_{8}$ inches (10 x 13 cm)

p. 66, top left, Tea for Two: 5^{7}/$_{8}$ x 8^{1}/$_{4}$ inches (15 x 21 cm)

p. 66, top right, Camels: 3^{15}/$_{16}$ x 3^{15}/$_{16}$ inches (10 x 10 cm)

p. 70, bottom, Order in Chaos: 9 7/$_{16}$ x 6 1/$_{8}$ inches (24 x 15.5 cm)

p. 71, die Spitze: 4^{11}/$_{16}$ x 7^{7}/$_{8}$ inches (12 x 20 cm)

pp. 72–73, Rooster and Hen: each 4^{15}/$_{16}$ x 6^{1}/$_{8}$ inches (12.5 x 15.5 cm)

p. 74, top right, Fish on Break: 6^{7}/$_{8}$ x 9^{1}/$_{4}$ inches (17.5 x 23.5 cm)

p. 76, Mr. and Mrs.: 7^{1}/$_{16}$ x 8^{5}/$_{8}$ inches (19 x 22 cm)

pp. 77–79, A Gallery of People: 4^{1}/$_{8}$ x 8^{1}/$_{4}$ inches (10.5 x 21 cm)

p. 80, top, On the Top: 5^{1}/$_{8}$ x 7^{1}/$_{16}$ inches (13 x 18 cm)

p. 84, Memorial Collage: 6^{5}/$_{16}$ x 8^{1}/$_{4}$ inches (16 x 21 cm)

p. 86, top right, Hostess Gift: 5^{11}/$_{16}$ x 8^{1}/$_{4}$ inches (14.5 x 21 cm)

p. 87, top, For a Book Lover: 3^{15}/$_{16}$ x 4^{5}/$_{16}$ inches (10 x 11 cm)

p. 88, Pull Tab to Open: 3^{9}/$_{16}$ x 4^{5}/$_{16}$ inches (9 x 11 cm)

p. 91, Anniversary Card: 5^{1}/$_{2}$ x 7^{1}/$_{16}$ inches (14 x 19 cm)

p. 92, left, Congratulations: 5^{11}/$_{16}$ x 9^{13}/$_{16}$ inches (14.5 x 25 cm)

p. 93, Fiction: 8^{1}/$_{4}$ x 11^{13}/$_{16}$ inches (21 x 30 cm)

p. 94, bottom, Egyptian Inspiration: 5^{1}/$_{8}$ x 7^{1}/$_{16}$ inches (13 x 18 cm)

p. 96, Fiction: 6^{5}/$_{16}$ x 9^{5}/$_{8}$ inches (16 x 24.5 cm)

p. 99, Postcard: 5^{1}/$_{8}$ x 4^{5}/$_{16}$ inches (13 x 11 cm)

p. 101, Chaos: 8^{5}/$_{8}$ x 10^{7}/$_{16}$ inches (22 x 26.5 cm)

p. 103, No. 30: 8^{7}/$_{8}$ x 6^{1}/$_{8}$ inches (22.5 x 15.5 cm)

p. 104, bottom, Congratulations: 7^{1}/$_{16}$ x 3^{3}/$_{4}$ inches (18 x 9.5 cm) (1:1 scale)

p. 105, top, Icon: 4 1/$_{2}$ x 7 1/$_{16}$ inches (11.5 x 19 cm)

p. 109, Recipe Collage: 5 7/$_{8}$ x 7 7/$_{8}$ inches (15 x 20 cm)

p. 110, top, Postcard: 5 1/$_{8}$ x 7 7/$_{8}$ inches (13 x 20 cm)

p. 111, Zebra Collage: 6 11/$_{16}$ x 3 9/$_{16}$ inches (17 x 9 cm)(1:1 scale)

p. 113, Nostalgia: 8 1/$_{2}$ x 10 7/$_{16}$ inches (21.5 x 26.5 cm)

p. 115, top, rRecipe Collage: 7 7/$_{8}$ x 5 7/$_{8}$ inches (20 x 15 cm)

p. 116, Dreams: 6 7/$_{8}$ x 4 15/$_{16}$ inches (17.5 x 12.5 cm)

p. 119, top, Birthday Card: 6 11/$_{16}$ x 4 11/$_{16}$ inches (17 x 12 cm)

p. 119, bottom, Birthday Card: 7 7/$_{16}$ x 5 1/$_{2}$ inches (19 x 14 cm)

p. 120, Carte Postale: 7 1/$_{16}$ x 4 1/$_{2}$ inches (18 x 11.5 cm)

Christine's collages

INDEX